P9-CEZ-867

IMAGES
of America

WESTPORT

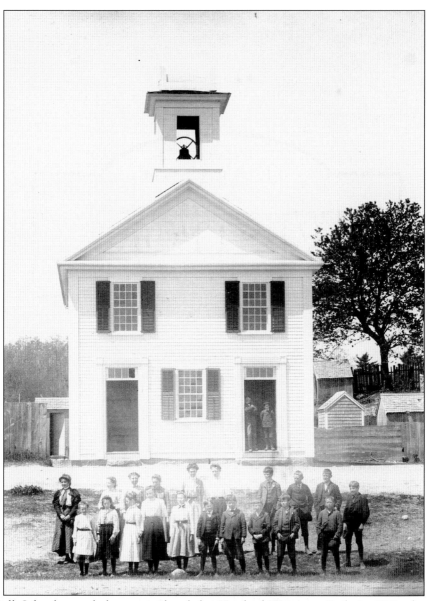

The Bell School served the west side of the Head of Westport. Built in 1841, the grand Greek Revival–style building symbolized a competitive spirit between the east and west sides of the village. In 1909, the second floor became a library, while the lower floor hosted entertainments and social events. Alumni Hall, as it was then known, had a unique stage curtain bearing advertisements of local businesses. It is now the headquarters of the Westport Historical Society.

On the cover: The town landing, composed of a large area on both sides of the river, was laid out in 1712. Once supporting shipbuilding, the landing later became a much-loved spot for many kinds of recreation from swimming and boating to fairs. Watering places pictured here allowed horses easy access to the river and also accommodated the "putting in" and "taking out" of small boats and the loading of scows. The right of Westport and Dartmouth residents to use the landing was formalized in 1788. (Courtesy Westport Historical Society.)

IMAGES
of America

WESTPORT

Westport Historical Society

ARCADIA
PUBLISHING

Copyright © 2008 by Westport Historical Society
ISBN 978-0-7385-5667-3

Published by Arcadia Publishing
Charleston SC, Chicago IL, Portsmouth NH, San Francisco CA

Printed in the United States of America

Library of Congress Catalog Card Number: 2007942999

For all general information contact Arcadia Publishing at:
Telephone 843-853-2070
Fax 843-853-0044
E-mail sales@arcadiapublishing.com
For customer service and orders:
Toll-Free 1-888-313-2665

Visit us on the Internet at www.arcadiapublishing.com

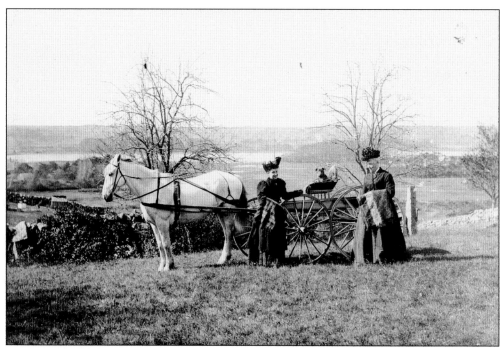

Pausing to have their photograph taken, two women stand while their dog sits comfortably in the buggy. Stone walls, typical of Westport, stretch down to the wide expanse of the Westport River in the distance.

CONTENTS

Acknowledgments 6

Introduction 7

1. The Head of Westport 9

2. Westport Point 25

3. Westport Harbor 43

4. South Westport 57

5. North Westport and Westport Factory 73

6. Horseneck 89

7. Central Village 105

8. Country and Community Life 117

ACKNOWLEDGMENTS

This book is a timely celebration of the Westport Historical Society's rich collection of over 3,000 photographs and postcards. This project is also a tangible and exciting product of many hours of work donated by volunteers to catalog and digitize our photographic collection and to transform it into a valuable research archive for all. It has been both a challenge and a delight to present here only a fraction of the entire collection.

We are grateful for the expert knowledge and meticulous research by our team of authors and advisors, many of whom also contributed images from their own personal collections: Tony Connors, Anna Duphiney, Russ Hart, Norma Judson, Cukie Macomber, Barbara Moss, Jenny O'Neill, Carol Schene, and Betty Slade. Many other individuals have generously offered photographs and their contributions are gratefully acknowledged in the text. Finally we acknowledge a debt to all Westport historians—their expertise and publications have been an invaluable resource for this project.

This is also an opportunity to recognize those pioneering photographers of the early 20th century. One Westport individual, John W. Howland (1848–1919), has left an outstanding legacy of compositions and many of the images presented here are his work. The identities of other photographers are unknown. We see the past through their eyes.

—Pres. Tony Connors and director Jenny O'Neill

INTRODUCTION

Geography does not necessarily determine the way the history of a place unfolds over time, but in Westport, the location had been the single most important factor in the town's development. Two rivers, from the northeast and the northwest, meet to form a protected harbor with an outlet to the ocean, and the southern edge of town is graced by a long sandy beach. Long before European settlement in the 17th century, members of the Wampanoag nation used the area for farming and fishing, and we still use the native word *quahog* for the hard-shell clams that form the basis of local chowders. From the Wampanoag we also get the original names for our rivers, the *Noquochoke* and the *Acoaxet*, now known by the more commonplace names of east branch and west branch of the Westport River.

The land that comprises modern-day Westport became known to Europeans after English explorer Bartholomew Gosnold surveyed the area in 1602 and attempted to establish a settlement on the island of Cuttyhunk, just a few miles off Westport's southern tip. When Plymouth Colony was established in 1620, Westport's location as the westernmost port in the colony provided its name. Many of the earliest settlers were Quakers, who built a meetinghouse in Westport in 1716. One noted Westport Quaker was Paul Cuffe, a black mariner and businessman whose humanitarian impulse led him to carry freed slaves to the African colony of Sierra Leone. In 1664, when the town of Dartmouth separated from Plymouth, Westport was a part of Dartmouth, and remained so until 1787, the year that Westport was incorporated as a distinct town. Various other border adjustments with Fall River and the state of Rhode Island occurred over the years, and by the end of the 19th century, Westport had settled into its current boundaries.

In colonial times, Westport was sparsely populated; what little settlement may have existed was destroyed in King Philip's War of 1675–1676. As English settlements expanded after the war, isolated farms developed in the Westport area. The earliest known house, a "Rhode Island Stone-Ender," dates from 1677. Only the chimney remains, although a drawing of the original Waite-Potter house is displayed on the Westport town seal. More farms were developed, and over time, people began clustering in villages, particularly at the Head of Westport (the head of the tidal waters of the east branch of the Westport River) and Westport Point (where the two branches meet). The Head of Westport had natural resources and roads that made it suitable for supplying the burgeoning New Bedford whaling industry with iron and wood products from its water-powered forges and sawmills and soon became a hub of commercial and maritime activity. Westport Point became a whaling center with as many as 22 whaling ships that called Westport home in the 19th century.

Situated between the commercial cities of Fall River and New Bedford, the north end of Westport was another locus of development. At the west end was a section of North Westport

known as the Narrows, a lively spot for business, entertainment, and recreation on the shores of North and South Watuppa Ponds. At the east end was Westport Factory, a village that grew up around the mills of the Westport Manufacturing Company, the town's largest employer in the late 19th and early 20th centuries. Westport's cotton industry, while small in comparison to those in neighboring Fall River and New Bedford, added to the local economy and brought hundreds of immigrants to the area, families whose descendants have been woven into the social fabric of the town.

After the whaling industry began to decline in the mid-19th century, Central Village rose in importance. This aptly named village, with its stores, offices, and town hall, became the administrative and commercial center of the town. Other villages, such as South Westport and Westport Harbor, retained their rural character while becoming places for summer recreation, particularly the inviting three-mile stretch of sand and waves at Horseneck Beach. Large resort hotels and private homes along Horseneck and East Beach, as well as riverside summer cottages, were built as people from Fall River, New Bedford, and well beyond came to enjoy the tranquility and fresh sea air of Westport. The resort era came to an abrupt end in 1938 when a devastating hurricane swept away hotels, homes, boats, and people. Other damaging hurricanes followed in 1944 and 1954, and even though the hotels never returned, Horseneck Beach remains a prime summer destination, and vacation cottages still dot the banks of the rivers.

While water seems to define the image of Westport, the land itself is very productive, and farming has been a long tradition as well as a current feature of the town's landscape and economy. Westport farmers even developed their own special vegetable, the Macomber turnip. A drive along Westport's back roads reveals our bucolic dairy and vegetable farms, produce stands, and orchards. Artisan cheeses and award-winning wine are made here, and the agricultural fair is still an important and enjoyable annual event. With a population density of less than 300 people per square mile, Westport remains a rural town despite the pressures of development.

Because the people of Westport traditionally identified with particular villages (which to some extent is still true today) that is how we have organized this book. From the busy commercial and entertainment area of North Westport to the old whaling port at Westport Point, from the lovely summer homes of Westport Harbor to the horse farms and beaches of South Westport, from the original iron forge and boat-building center at the Head to the administrative hub at Central Village—and always the rivers and the sea—here is Westport, Massachusetts.

One

THE HEAD OF WESTPORT

A stalwart pioneer homesteaded beside a rushing river, and the site that was to become the Head of Westport, the first of eight villages in town, was established. The year was 1671, and the man was Richard Sisson. The village name stemmed from the fact that here was the head of the tidal waters that ebbed and flowed from the ocean some 10 miles distant.

Native Americans camped here, and their trails, which are today Route 177 and Old County Road, reached out in all directions, connecting the Head of Westport to Rhode Island and Cape Cod. This overland trade route encouraged the development of a settlement at the Head. Waterpower was also important to the Head of Westport's development in the 1700s. The river, which dropped nearly 40 feet just before the Head of Westport, provided consistent and abundant energy to power mills.

The Head of Westport maintained a close connection to the sea. Lively river commerce brought in commodities from the outside world, while the village's goods traveled seaward. Many whaling masters were native to the Head of Westport, numbering 23 by the mid-1800s.

Never an agrarian community, the Head became a center for commerce and industry. At the height of its prosperity, in the 1800s, stores provided goods and services from harnesses to millinery; inns and taverns flourished; and schools, a library, and churches were established. Ships were built on the town landing beside the river, and the hulls floated down river. One historian notes that on launching days the drinks were free, and the men and boys indulged in a wild day of celebration. By the mid-19th century, the wealth and aspirations of retired whaling masters and ship-owners had transformed the Head of Westport from a center of industry into a genteel community. Successful whaling masters bestowed a rich and enduring architectural legacy in Westport. They are responsible not only for some of the grander Greek Revival–style homes at the Head of Westport, but they also helped to establish some of the key social institutions such as schools, the Pacific Union Congregational Church, and Washingtonian Hall, a temperance society. The town landing, embracing both sides of the river, became a scenic spot open to all for recreation.

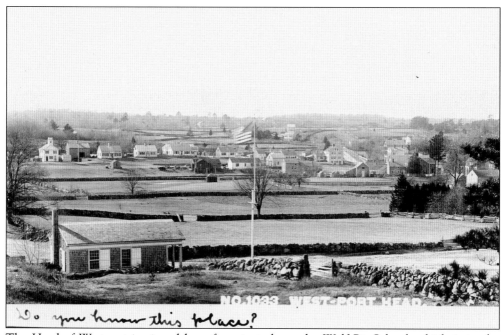

Do you know this place?

The Head of Westport is viewed here from just above the Wolf Pit School, which is in the foreground. In the distance across open fields defined by stone walls, the Bell School and houses along Drift Road can be seen.

Over a dozen mills, including sawmills, gristmills, shingle and carding mills, developed along the river. Among these was Lawton's Mill, a combination gristmill and sawmill located on the east side of Gifford Road just above the village. No single individual was to be allowed to own such a valuable resource, and thus a trio of settlers, George Lawton, Benjamin Waite, and John Tripp, built the mill in the mid-18th century.

The milldam (below) and millpond (above) are pictured here. The millpond covered 43 acres. This mill operated for over 200 years. The property passed through several hands finally to Charles E. Brightman, who eventually moved out of town. The last known mill operator was A. Clifton Hart of Tiverton who lived in the house with his family in the 1920s.

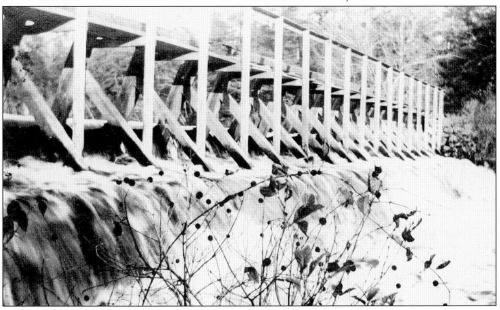

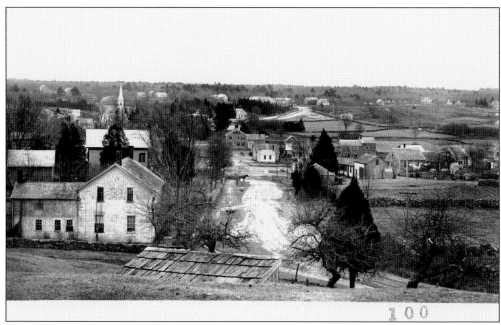

This winter view is looking eastwards down Old County Road, which was referred to as Main Street in the early 1900s. The Wolf Pit School and flagpole stand in the distance, partially obscured by trees.

George White's tin peddler cart climbs the "road over the hill" overlooking the town landing. Pictured here are houses on Drift Road, overlooking the landing, built between the late 1700s and the early 1800s. The Bell School appears at the far end of the road.

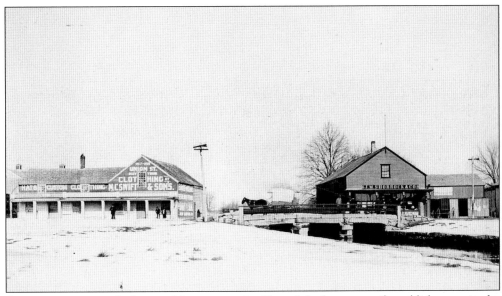

Country stores were the heart of the community. Two of the largest retail establishments in the village were, to the right, Charles A. Gifford's, built in 1889 and last owned by Joseph Shorrock; and to the left, Peckham and Howland's, opened in 1821, each strategically located at opposite ends of the granite bridge. It is unclear when the first bridge was built; however, in 1794 the town discussed building a new one. A new bridge was constructed in 1813, which was replaced in 1962. (Courtesy of Anna Duphiney.)

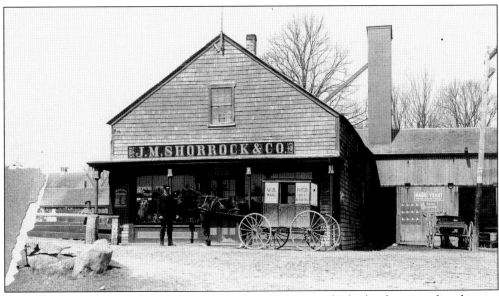

The rural free delivery wagon waits outside Shorrock's store, which also functioned as the post office. Advertisements for Wheaton's famous bottled soda water, Ayer's sarsaparilla, and Magic Yeast adorn the store. Other goods found in this store included boots, paints, oils, varnishes, window glass, hay, grain, and crockery.

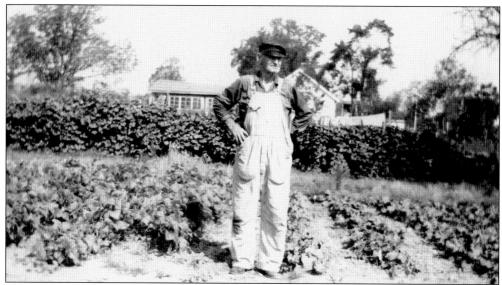

Retired whaling master Charles A. Chace poses in his vegetable garden at 15 Drift Road where he lived at the home of his sisters, Kate Tallman and Lydia Chace. Chace began his whaling career on ships captained by his father. He went on to command several whaling vessels including *Andrew Hicks* and *Sunbeam*. Chace often said his favorite port was Barbados because of its exceptional climate. He died in 1956 at the age of 91. (Courtesy of Russell N. Sherman.)

This structure, known as the powder house, originally stood on the east town landing set back from the river. Built around 1813 as a storehouse for the Home Guard's ammunition, it housed rifle balls used in muzzle-loading muskets for another 150 years. In 1972, the Westport Historical Society moved the building to the center of the town landing triangle in an effort to preserve the structure.

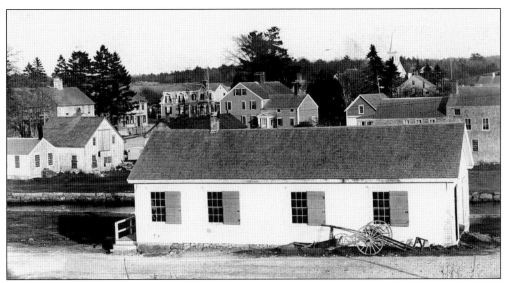

Built in 1840, Washingtonian Hall was originally a center for the temperance society and was located on the west side of the town landing. Like many buildings, it underwent several changes in function and location. The building later became a community center, known as Riverside Hall.

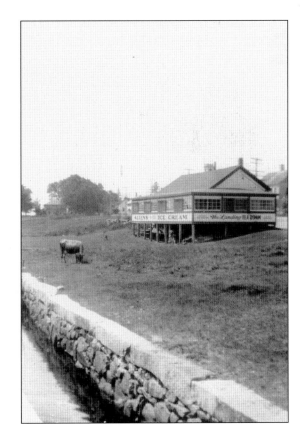

A cow grazes peacefully on the town landing. David Allen purchased Washingtonian Hall and operated a tearoom and ice cream parlor known as the Landing from 1929 to 1935. The structure was moved later to the north side of Old County Road. (Courtesy of Alice May Allen Laberge.)

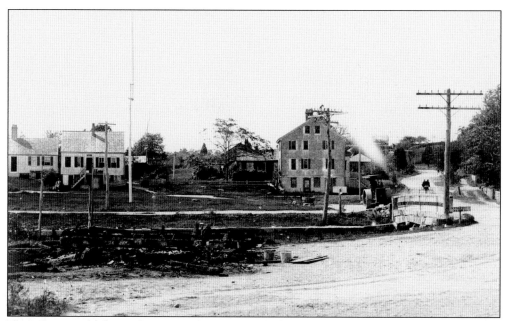

This photograph shows the ruins of Hiram Reed's harness shop. The wood stove and metal chimney can be seen in the debris. The steam-powered road roller is on the west side of the bridge, and the water pump and water trough can be seen on the triangle. A flagpole stands where today the Powder House is located. A sign on bridge reads "Dangerous Passing."

A group of small buildings clustered on the east landing near the bridge, including Hiram Reed's harness shop and Isaac Francis' barber shop. The stone wall of the blacksmith shop is on the far left, and the Powder House is glimpsed behind these buildings in its original location.

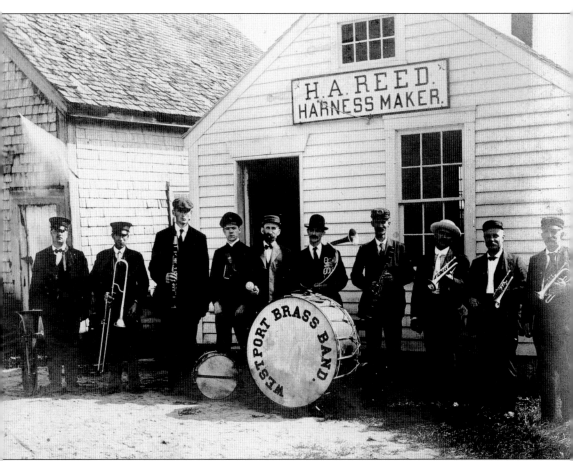

The Westport Brass Band poses with instruments in front of Hiram Reed's harness shop. Formed in the 1890s, the popular band provided entertainment at events in the area. Of those identified in this photograph, George Gifford (fifth from left) and George Sherman (fourth from right) were original officers of the group. Hiram Reed (second from right) and George Tripp (right) were also original members.

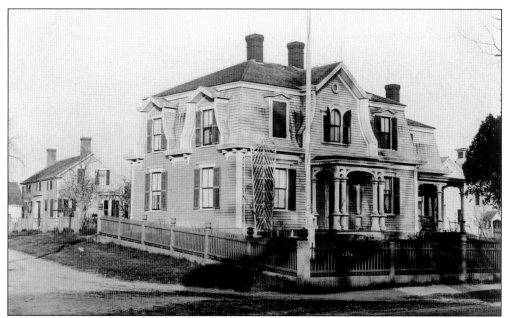

In contrast to the modest design of earlier houses along upper Drift Road, many of those along Old County Road were elegant in a variety of styles including Georgian, Italianate, Federal, and Gothic Revival. Pictured here is a center-gabled Second Empire home located at 504 Old County Road, built about 1870 by J. L. Anthony, a prominent local merchant.

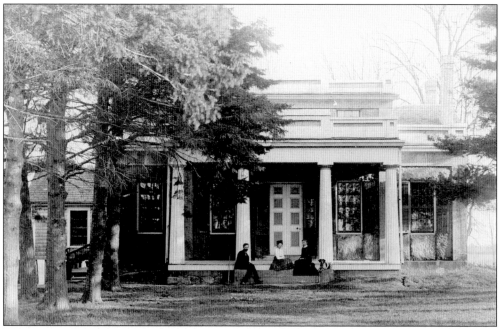

The year of the construction and identity of the builder of this grand stone house, fashioned of local granite, and its equally grand stone wall, differ according to historical sources. Whether or not Capt. Stephen Howland spent his fortune in building his dream home in 1793, or Humphrey Howland did the same in 1830, it is agreed that the impoverished widow operated a tavern and inn here for several years.

Over the years, a number of medical doctors lived and practiced at the Head of Westport. One of them, Dr. John D. Tupper, operated a hospital in this home, located at 552 Old County Road at the beginning of the 20th century.

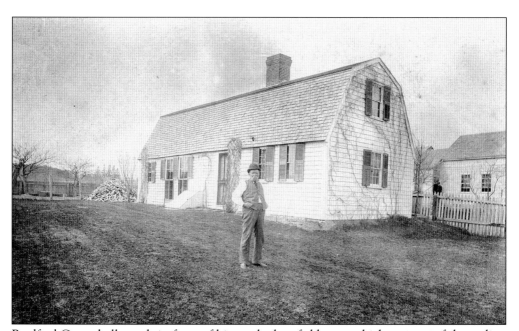

Bradford Coggeshall stands in front of his gambrel-roofed house, which was one of the earliest homes at the Head of Westport. The original part of the structure probably dated back to the 17th century. It stood on Reed Road and was dismantled and moved to Newport.

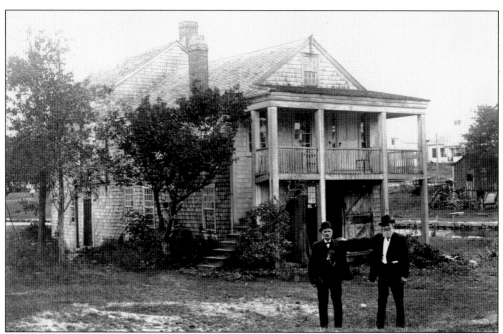

Barjona and Alonzo Tripp stand outside the carriage shop on the east landing in which they learned their trade. Alonzo Tripp built a wheel that was 14 feet high for one of the local mills.

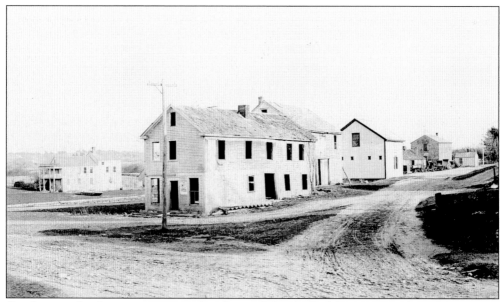

On the west landing, once it ceased to be used for shipbuilding, a row of small businesses developed including Charles Reckard's blacksmith shop where special attention was given to "shoeing tenderfooted and interfering horses," a harness shop, and cobbler's shop.

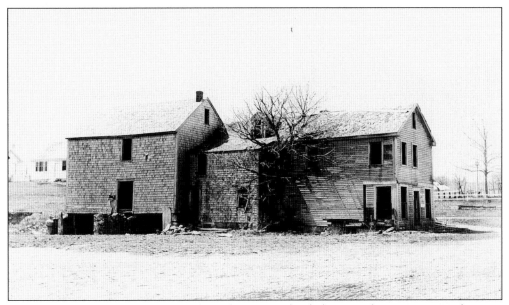

This is a prime example of photographer John W. Howland's keen eye for interesting and artistic scenes. This derelict building stood on the triangle where Old County and Drift Roads meet.

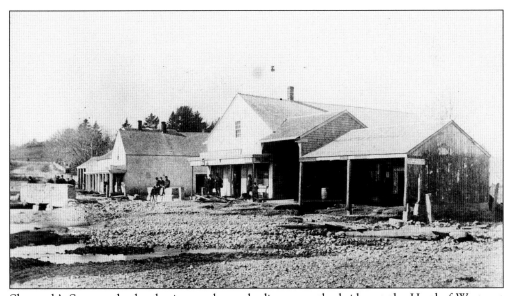

Shorrock's Store and other businesses located adjacent to the bridge at the Head of Westport experienced flooding when a freshet inundated the area leaving behind a carpet of stone and earth. The event pictured here occurred on February 12, 1886.

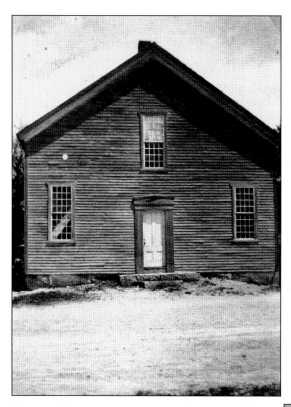

This building, which no longer exists, has been identified by local historians as the Baptist, or First Christian Church, which stood on Old County Road. In 1819, elder Daniel Hix of Dartmouth acknowledged this group as the First Christian Church. It was the first of five such churches in Westport.

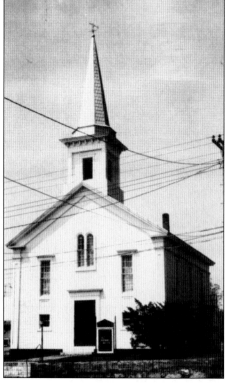

The Pacific Union Congregational Church was built in 1856 by a group of village merchants who were its initial stockholders. At its inception the shareholders voted, though not nearly unanimously, to embrace Congregationalism. The first minister to serve the new house of worship was Dr. John B. Parris. Of at least three churches once at the Head of Westport, Pacific Union Congregational Church is the sole survivor. (Courtesy of Anna Duphiney.)

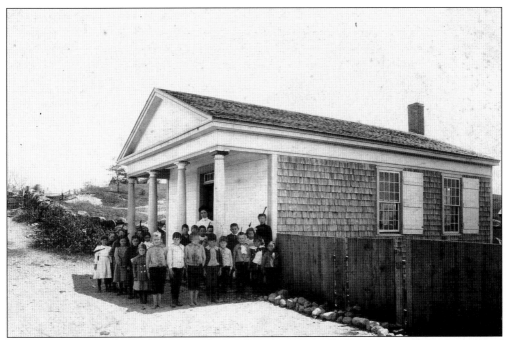

The Wolf Pit School, also known as the Little School, served the children of the east side of the river. Built in 1833, the tiny one-room schoolhouse is the oldest standing school building in Westport. Over the years, the building has been used as a library, as a WPA center, and for the distribution of ration stamps during the Second World War. The building was restored in 2006.

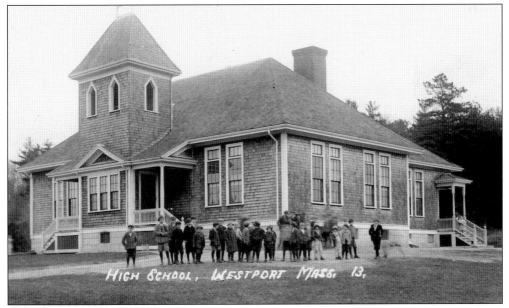

By the early 1900s, Westport was in the process of modernizing its school system and built several large schools to replace the many one-room school buildings that were scattered across town. Completed in 1907, this building is located on Reed Road and served grades one through six. Today it is the headquarters of the Council on Aging.

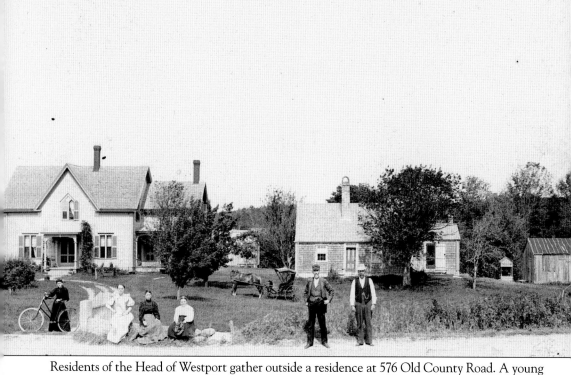

Residents of the Head of Westport gather outside a residence at 576 Old County Road. A young woman shows off her bicycle. This was the home of Dr. Edward Burt, who masterminded Old Home Week in 1908.

Two

WESTPORT POINT

Westport Point, also known as the Point, a peninsula jutting into the Westport River, was a Native American summer location for farming and fishing. When the first Europeans explored, they found cleared farmland and rich fishing grounds, but no Europeans lived there before 1700 when Quakers began to acquire land. In 1720, only Christopher Gifford's house stood at lower Westport Point. This area was to become an ideal site for shipping, privateering, wharves, and the new industry of whaling with its associated activities of coopering, shipbuilding, and blacksmithing. By 1800, there were 15 houses, new wharves, artisan shops, general stores, a windmill, and a distillery.

After the War of 1812, wealthy seafaring captains built large Federal and Georgian houses. In the 1840s, the height of whaling, Greek Revival homes were the rage, and Westport Point was booming. However with the decline of the whaling industry after the Civil War, the economy of Westport Point became depressed. Later as the nation prospered and transportation improved, Westport Point began to be recognized as a desirable summer vacation spot, which provided tourist income for farmers, fishermen, boat builders, and others. People from outside Westport began to buy second homes at Westport Point or to convert smaller houses or barns into larger summer cottages. By 1914, it was a true village with 75 houses, a school, the Methodist church and the cemetery, three stores, the wharves, and a post office. The closest trolley line was 10 miles away, so it remained somewhat isolated, which served rumrunners well during Prohibition. Al Capone came several times to Westport Point during rum-running days.

Westport Point always had its share of memorable characters. Artists Clifford Ashley, Helen Ellis, Mary Hicks Brown, and Mercy Etta Baker lived here, as did miniature furniture maker John Babcock, and John L. E. Pell, author of *Down to the Sea in Ships*. Earlier settlers with names of Allen, Earle, Gifford, Brightman, Cory, and Palmer still have descendants in the village. Despite its popularity, Westport Point has retained the look of the 1800s, and in 1973 it was designated a historic district.

The village in the early 1920s still has the oil-fired streetlights, but electric poles have been newly installed. The home of Philip and Kate Cory Grinnell is on the right nestled up against Thanksgiving Lane, which led to a house on the river owned by an Oxford scholar, William Watkins, in 1783, where the first Westport Point school was established. The Cory Store (Paquachuck Inn) can be seen at the end of the street on the left.

Constructed in 1827 by Isaac Cory, this building was central to the commercial life of Westport Point. The first floor served as a general store, with a millinery store, tailor shop, and sail loft upstairs. In the 1830s, it was the customs office and later a post office. In the 1950s, it was converted to an inn, now known as the Paquachuck Inn, a name derived from the Wampanoag term for this locale.

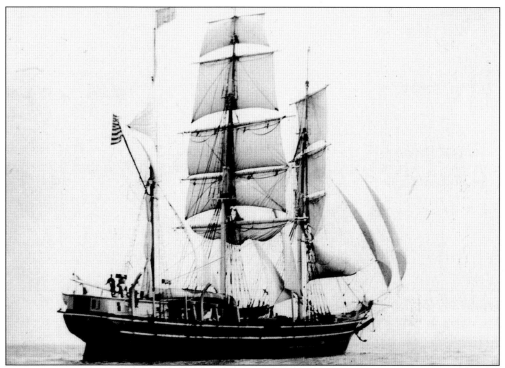

Launched in 1855, the *Mermaid* was one of several whaling vessels built by Frank Sisson and Eli Allen in their shipyard behind the Cory Store. In 1856, Allen and Sisson constructed the *Kate Cory*, the last Westport-built whaling vessel. Originally a schooner, she was converted to a brig and was burned off the coast of Brazil in 1863 by the Confederate commerce raider *Alabama*. (Courtesy of New Bedford Whaling Museum.)

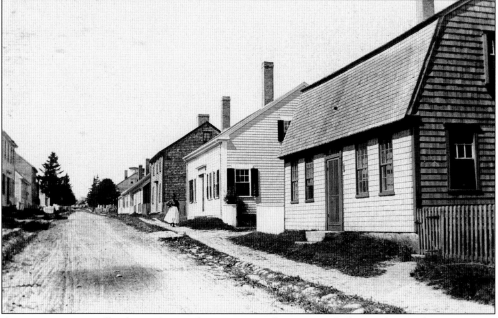

A young woman walks down the southern section of Main Road, then a dirt road.

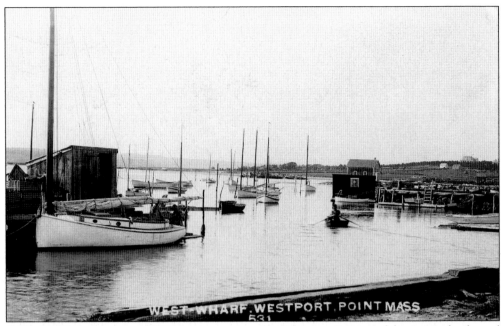

Catboats belonging to local fishermen are moored at Westport Point. A fisherman's shack used for storage of gear is shown at the far left standing on the stone pile.

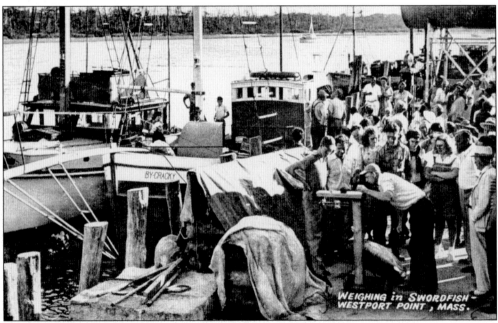

Weighing in swordfish was a special village event. Incoming boats raised flags to notify the town when they had swordfish. In this photograph from the mid-1940s, Albert Lees Sr. is weighing in a fish harpooned by Arthur Denault, behind, the owner of the *By-Cracky* nearby. Norma Judson, with the scarf around her neck, watches alongside Harry and Louise Richards, while Carl Lees watches his father.

28

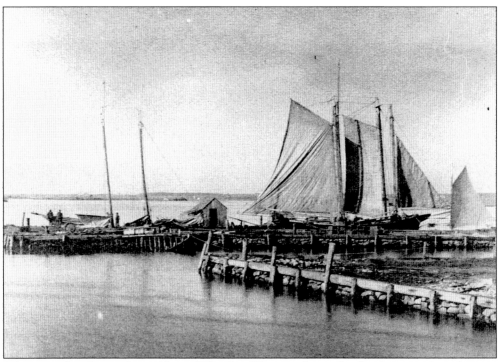

Schooners dry their sails at Almy's Wharf at Westport Point. In the foreground is what are now Lees Wharf and the mud dock. The small building on the stone pile is now known as the West Dock.

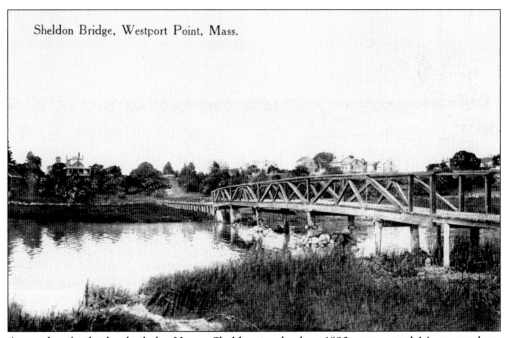

Sheldon Bridge, Westport Point, Mass.

A wooden footbridge built by Henry Sheldon in the late 1890s connected Masquesatch to Westport Point and was used as a shortcut. (Courtesy of George Dean)

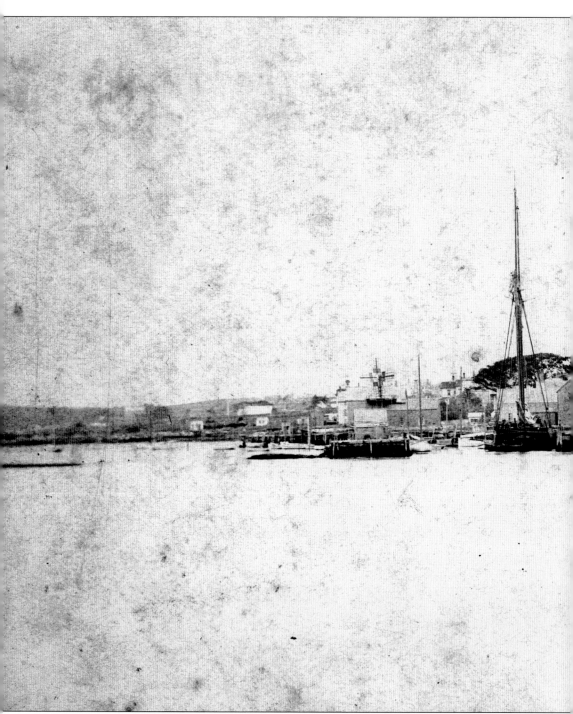

A typical day's scene from the Westport River shows the wharves and sailing vessels at the tip of Westport Point. Sailing vessels with their tall masts sit at the wharves. At the far left up the west branch of the river is the 1803 carriage house of Isaac Cory, small stores, blacksmith and cooper shops, a windmill-powered sawmill, and the storage buildings on the wharf. Looking up Main Road to the north there is the Cory Store, and further up, the cupola of a whaling captain's

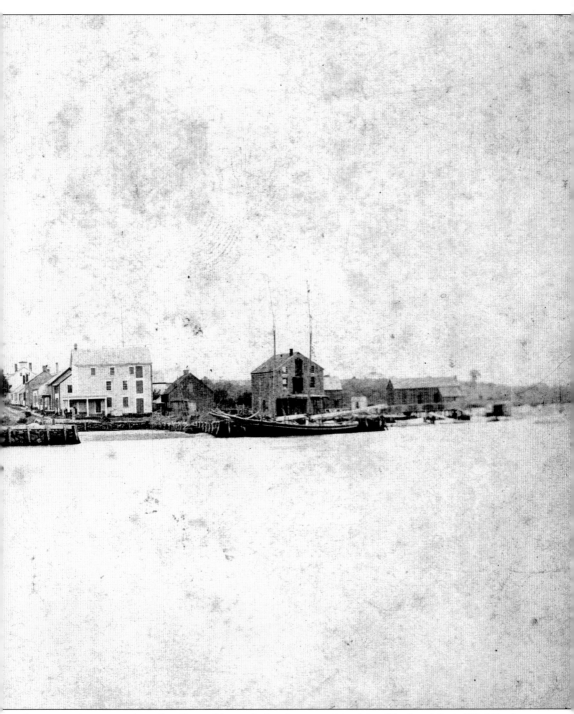

home can be seen, where family could watch for the returning ships. To the right is Eli Allen's shop, other stores, and the building that is now known as Lees Wharf building. Three brigs, the *Industry*, *Almy*, and *Mexico*, known as the father vessels, were major customers and are said to have made Westport Point a famous whaling town.

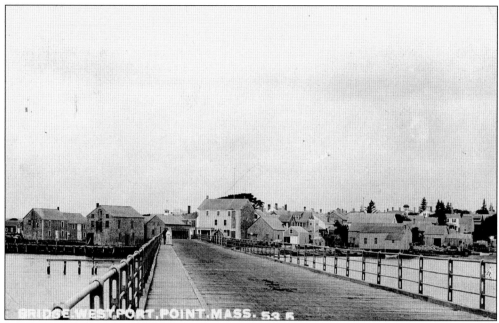

In 1894, a wooden, manually operated drawbridge was operational at Westport Point, allowing walkers and vehicles to pass to Horseneck Beach. There was much opposition to this bridge in Westport, but the South Westporters, led by Henry Brown, prevailed by going directly to the state legislature. It became a main thoroughfare for tourists and locals alike, with bumper-to-bumper traffic on weekends. The bridge was dismantled in 1963.

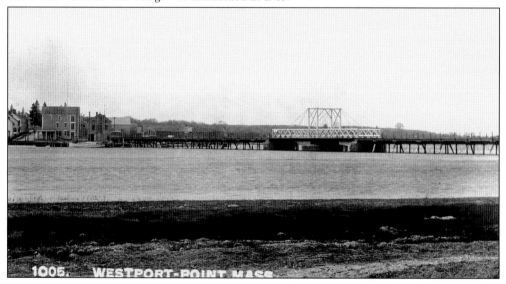

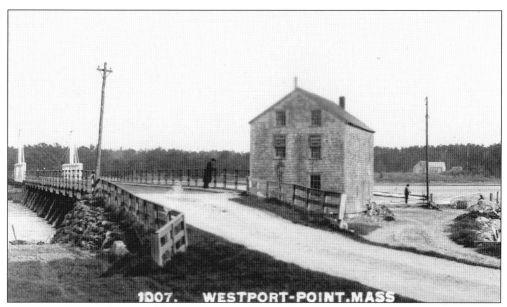

This view of the bridge from Westport Point looks south towards Horseneck Beach.

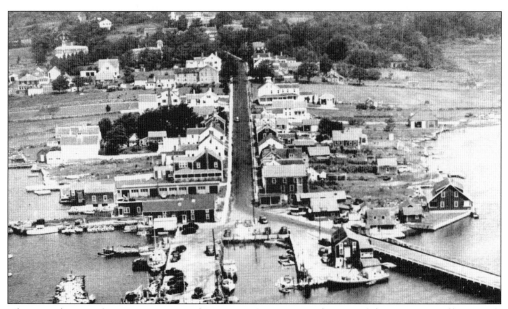

This aerial view of Westport Point taken in 1945 gives a good sense of the compact village, with the houses built very close to Main Road. At lower right are Lees Wharf and the old wooden bridge leading to Horseneck Beach.

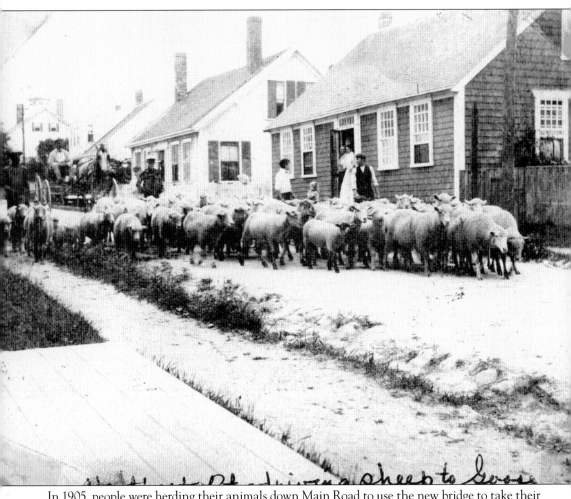

In 1905, people were herding their animals down Main Road to use the new bridge to take their sheep to Gooseberry Island for grazing. (Courtesy of Glenda Broadbent.)

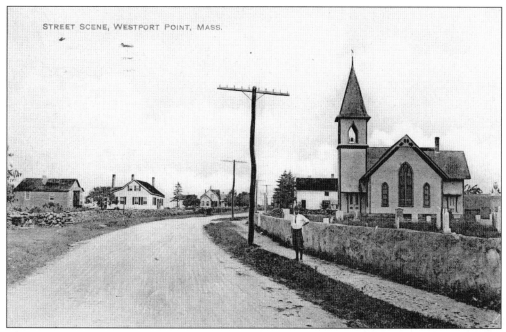

The Westport Point Methodist Church was built in 1883, the third edifice of a religious society that dates back to 1832. The cemetery associated with the church became the village cemetery, with many seafaring captains and crew and their families buried there. Stone walls lined this part of Westport Point which in early years was made up of farms, but over time houses were built, and the village population swelled.

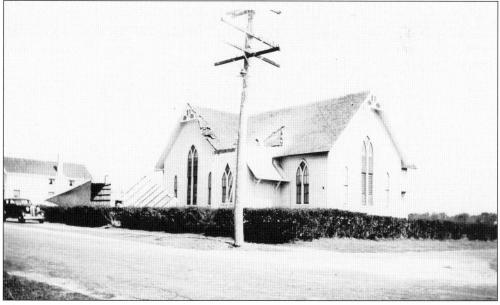

The Westport Point Methodist Church lost its spire in the 1938 hurricane. (Courtesy of Carolyn Cody.)

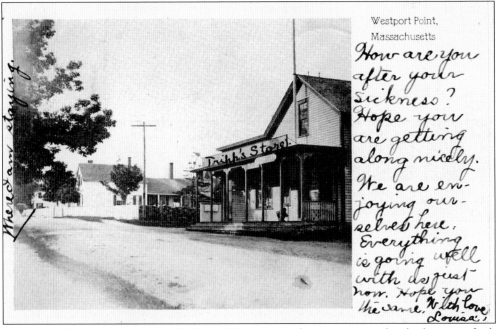

Westport Point,
Massachusetts

How are you after your sickness? Hope you are getting along nicely. We are enjoying ourselves here. Everything is going well with us just now. Hope you the same. With love, Louisa,

Where are staying

Several small stores sprung up in the late 1800s to serve the summer people who began to flock to Horseneck Beach and rent rooms at boarding houses and the Hotel Westport. The Tripp brothers ran a store (shown here) on the east side of Main Road in the early 1900s.

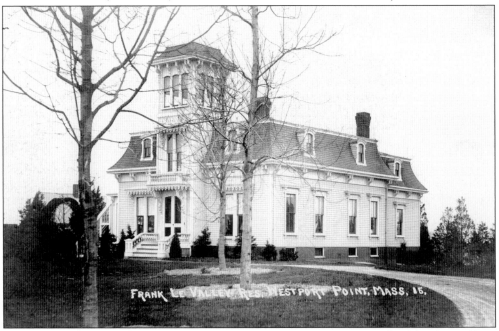

FRANK L. VALLEY RES. WESTPORT POINT, MASS, 15.

Local builder Fred Brown built this Second Empire, Italianate villa for New York banker William Valentine between 1865 and 1871. Henry and Alice Wing Sheldon bought the house in 1905 along with several houses and depressed farms in the area and brought in a number of Portuguese families to work the farms. Henry started a railroad stock company to build a line to Horseneck Beach but lost his fortune in the 1929 stock market crash.

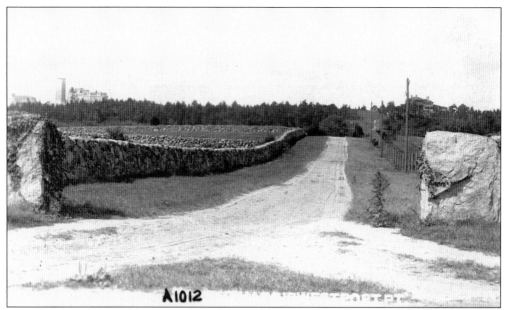

Henry Brown Esq. owned a large tract of land called Eldridge Heights, as well as holdings on Horseneck Beach. After his plans to develop a Coney Island–type tourist attraction failed, Brown sold two tracts, one to Rev. Charles C. Hall, who built "Synton" in 1889, and the other to George Southard, who built the "Junipers." Riverside Drive was lined with fine stone walls from Main Road to the river to provide access to these fine homes.

The Allens owned several lots at Westport Point and were active in the whaling industry. This photograph, taken about 1895, includes, from left to right, (first row) George Allen; Clara (Allen) Gifford; and Blanche Lake; (second row) Buster Lake; his grandmother, Abbie Bateman; Myrtle (Allen) Gifford; Julia (Brightman) Allen; William Allen; Maude Lake; and unidentified. Sitting in Clara (Lawton) Allen's lap is Etta Jane (Allen) Palmer, and the woman with the bicycle is Almira Tripp, whose mother was an Allen. (Courtesy of Russ Hart.)

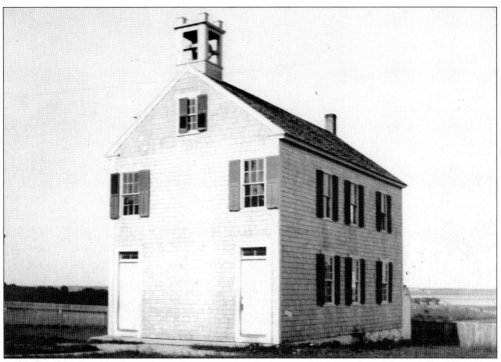

Westport Point had at least three different schools. Pictured here is the earliest school building. This design, complete with bell tower, is seen also in the Bell School, the original Westport Factory School, as well as the Russells Mills School in Dartmouth.

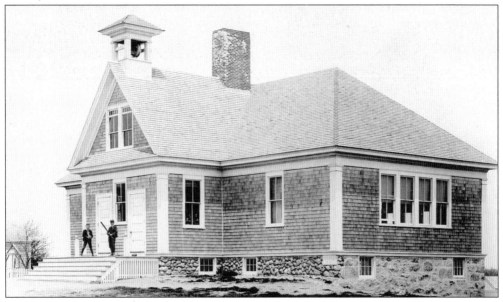

Built in 1904 for a sum of $4,300, this school originally had two large rooms, initially for four grades of elementary school, then reduced to two grades as other town schools developed. Students came from all parts of Westport, not only from Westport Point. A contemporary newspaper report noted, "it embodies the most modern methods of schoolroom architecture." It had a coal furnace and bathrooms were located in the basement rather than outhouses. Today it is a private residence.

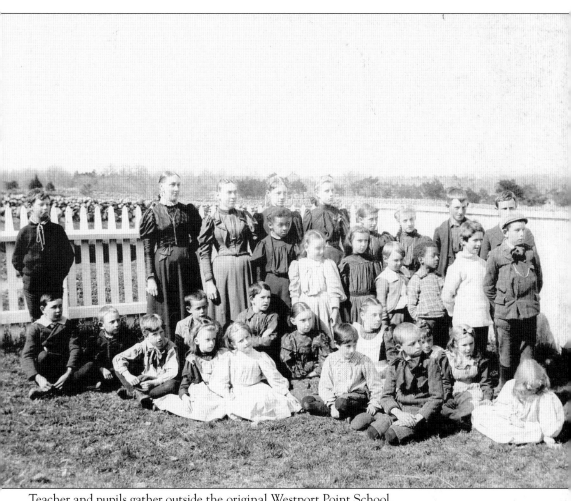

Teacher and pupils gather outside the original Westport Point School.

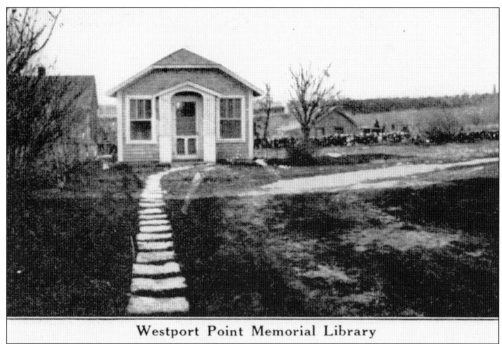

Westport Point Memorial Library

Oral history suggests there was a library at the Watkins home in the late 1700s, but this small lending library lives on in people's memories as the Westport Point library. It was founded by Katherine Hall in the 1920s. In addition to books, it had exhibits and artifacts from her father's travels all over the world. (Courtesy of Carolyn Cody.)

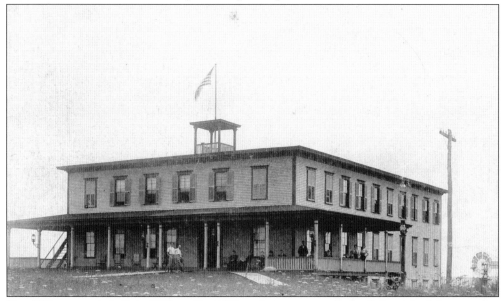

Hotel Westport was built in 1889, and by 1897, under new owner Rufus Baker, it had three stories, a stable, and a water mill. Among other services, visitors enjoyed modern conveniences such as electric bells, toilets with running water, baths, and excellent beds. The hotel was supplied with pure water from running springs. Most of the hotel burned in 1918, but the foyer and meeting rooms were spared and converted into a private home.

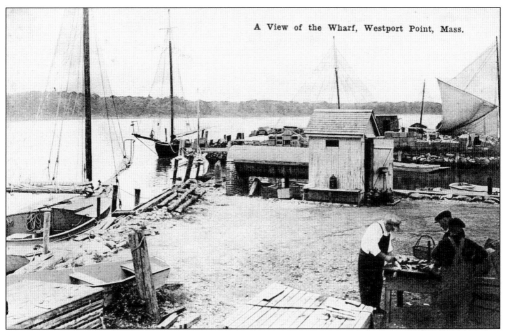

A View of the Wharf, Westport Point, Mass.

Thomas H. Mayhew, a ship's agent for many whalers, built the wharf around 1830 under license from the legislature. This 1920s photograph shows Whalon's (now Lees) Wharf. Men are busy filleting fish, mainly cod, to be salted and dried in the small building near them. It was still an era of sailing vessels, although motorized vessels had taken over much of the lobstering and swordfishing.

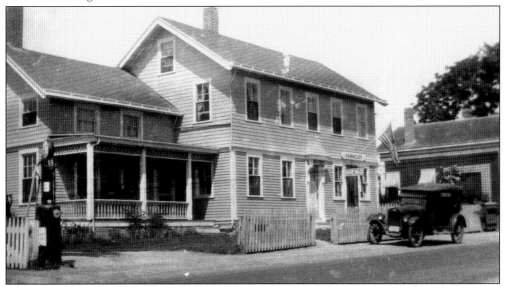

Most Westport villages had post offices. The Hammonds, who built this house about 1871, were early postmasters and postmistresses, and the profession stayed in the family for decades. Their post office was also a general store with a gas pump. The house still stands, across from the current post office. Westport Point was fortunate that people simply modified their homes slightly to accommodate the post office and thus preserved the small village environment. (Courtesy of Carolyn Cody.)

41

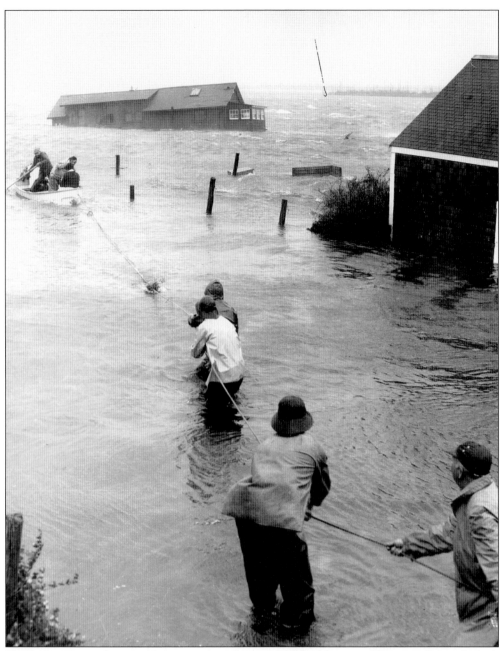

Hurricanes were always a threat to the wharves and buildings at Westport Point. Laura's Restaurant, a favorite eating spot close to the Point Bridge, was uprooted and carried away by Hurricane Carol of 1954. Jim Hickey, the bartender, was still in the building, leading to this dramatic rescue. The restaurant never reopened. (Courtesy of Paul and Cecile DeNadal.)

Three

WESTPORT HARBOR

Geographically separated from the rest of Westport by the west branch of the Westport River is Westport Harbor. The growth of this harbor, also known as Acoaxet, coincided with the heyday of Fall River's cotton mill industry in the early 1900s. With its rolling farmlands and scenic shoreline, Westport Harbor provided an idyllic escape for many of Fall River's prominent industrial and professional leaders such as Earle Perry Charlton, Charles Borden Chase, and Richard Kingsley Hawes. Whether staying at Sowle's Hotel, the Howland House, or their own grand cottages, they enjoyed a busy social scene including swimming, yacht racing, and fishing. In its early years, this summer community banded together to form the Casino Association to oversee the construction of an all-purpose assembly hall. This association later evolved into the Acoaxet Club.

Even in this tranquil setting, however, there were turbulent moments. In 1919, Westport Harbor residents initiated their own mini-revolution, attempting to secede from the town of Westport. Many harbor residents claimed that they were being overtaxed. It was observed that Reginald Vanderbilt of Sandy Point Farms in Rhode Island owned 100 acres and paid $450 while Earle P. Charlton, who owned 20 acres at Pond Meadow in Westport, had paid $4,240 in property taxes. The proposed separate town of Acoaxet would have encompassed three-and-a-half square miles with 100 residents. In 1926, town meeting attendees heatedly debated the issue. They voted unanimously to deny the secession.

During Prohibition, rumrunners made use of the harbor's secluded shoreline to bring in contraband. In 1925, 75 cases of Scotch whiskey were seized from a schooner that washed ashore near Acoaxet.

On September 21, 1938, a hurricane rated as one of the costliest disasters in United States history struck without warning. Winds in excess of 100 miles per hour caused great devastation to the summer colony. From the Point of Rocks to Brayton's Point, almost every house on the waterfront was completely swept away or damaged beyond repair.

Today Westport Harbor continues to be a popular vacation destination where beach cottages, and large residences provide visitors and residents with numerous opportunities to enjoy water activities and quiet summer days at the shore and on the river.

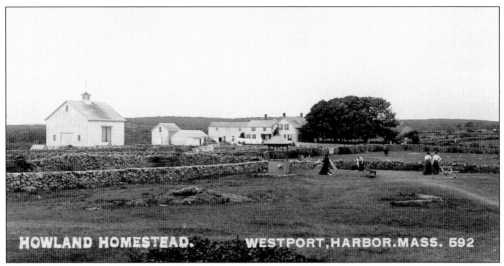

HOWLAND HOMESTEAD. WESTPORT, HARBOR. MASS. 592

A group of women stroll through the fields of Howland Farm. The Westport Harbor community was originally centered on farming. This idyllic rural setting attracted a wealthy group of summer residents who were prepared to invest in building their own facilities. Many of their summer cottages are pictured below.

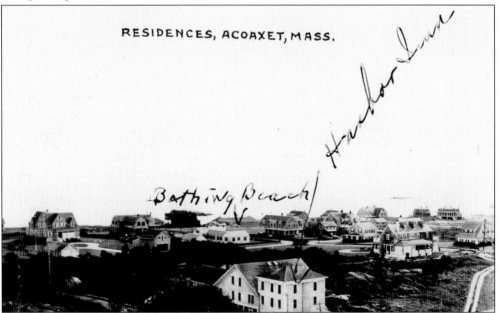

RESIDENCES, ACOAXET, MASS.

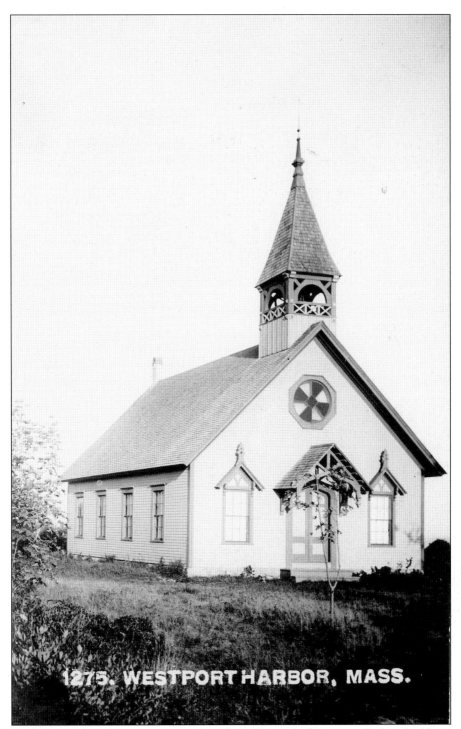

1275. WESTPORT HARBOR, MASS.

In 1872, the Free Chapel Association purchased a half-acre for $35 upon which to build a chapel. The chapel was "held in trust for the free use of all Protestant denominations for the worship of God and for moral and religious instruction." Designed by Caleb Hammond of New Bedford, the original Acoaxet Chapel burned down in 1883 but was rebuilt in the same year.

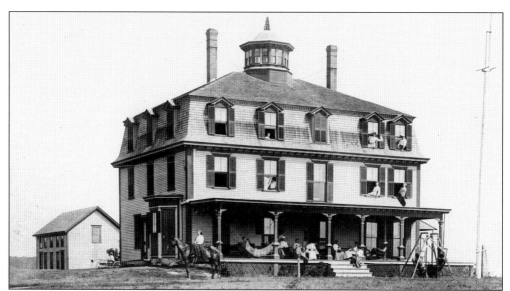

Known as Howland House, this three-story building with its mansard roof and octagonal widow's walk has served as both a hotel and private home. Built in 1880, it sits on a high ridge, which once overlooked farmland but now surveys the Acoaxet Club. It was the site of many elegant garden parties and masquerade balls. However the harbor retained its rural character. Pictured below, farmers harvest salt hay for their livestock. The Howland House and the distinctive domed outline of a hayrick can be seen on the horizon.

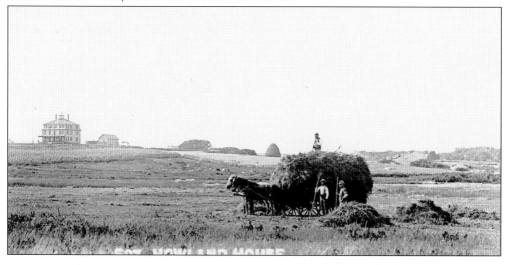

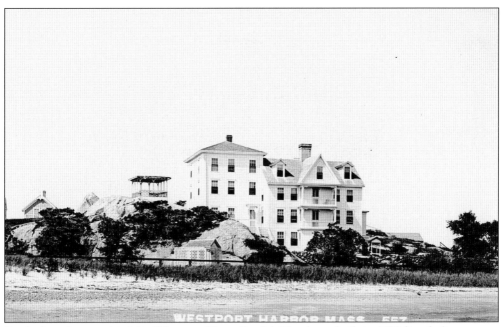

Perched at the mouth of the Westport River, Sowle's Hotel was built in 1873 by whaling master James M. Sowle (1824–1898). The hotel could accommodate 65 guests and had a large hall available for social and religious functions. Many visitors were drawn by the excellent striped bass fishing, and the hotel provided catboats at Sowle's wharf to facilitate convenient fishing. Most of the hotel was demolished after Captain Sowle's daughter Elizabeth sold it to Earle P. Charlton in 1911. One wing, however, was saved and became the north end of the Harbor Inn.

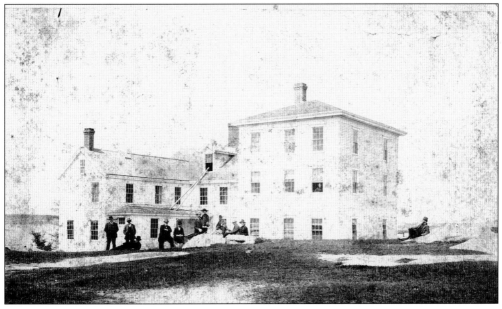

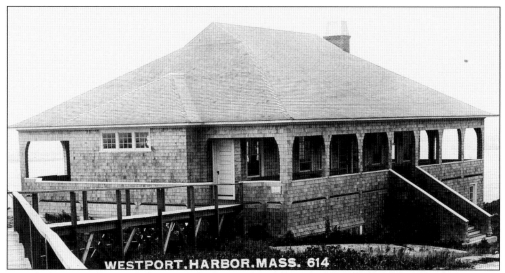

The Casino Association of Westport Harbor was formed in 1902. Summer residents who became subscribers to this association purchased land by Cockeast Pond to build a casino to accommodate expanding community activities. The casino became the center of social gatherings such as lobster suppers and plays by the Westport Harbor Dramatic Club. Each Saturday night locals gathered for dancing and were entertained until midnight by a five-piece orchestra.

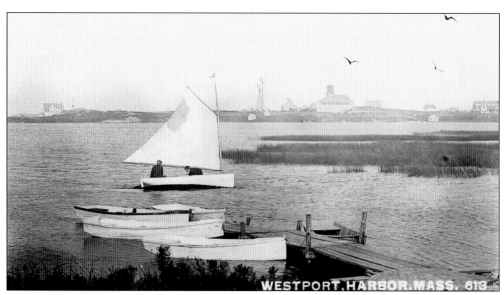

On the back of the postcard above, showing the casino in the distance, a visitor to Westport Harbor comments, "Just came from there—had a little dance and very pleasant time."

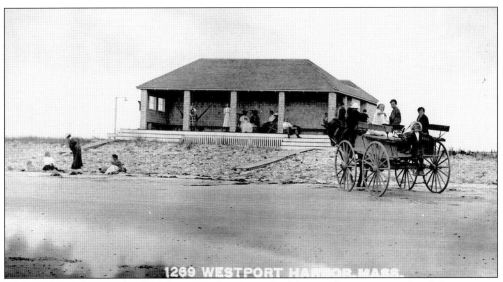

Built in 1894, the Howland Bathing Pavilion was a bathhouse that accommodated the summer residents and visitors to Westport Harbor. The harbor's annual field day for local children was held outside the pavilion in the 1920s. The pavilion was destroyed in the 1938 hurricane.

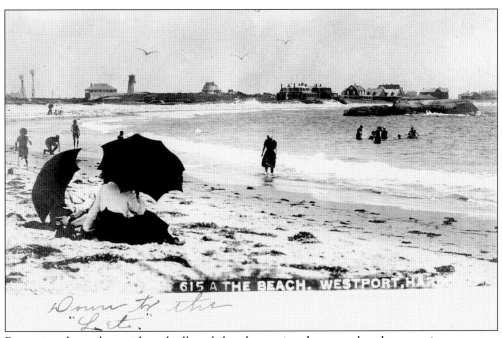

Protecting themselves with umbrellas while others enjoy the water, beachgoers enjoy a summer day. Several harbor landmarks are pictured in the distance. On the left stand windmills, the casino, and water tower. Beachfront cottages stretch into the distance.

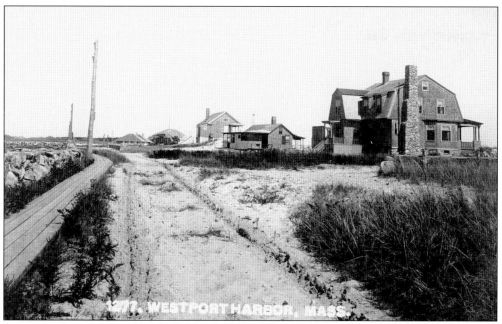

A boardwalk runs behind residences on the beach leading to the Point of Rocks.

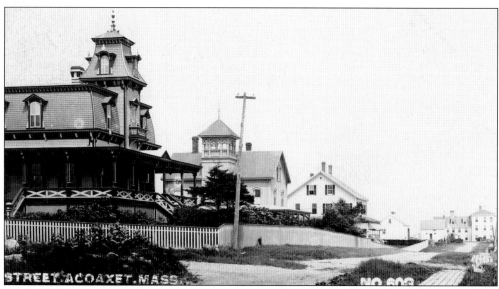

Pictured here on Prospect Street in 1906 is the Second Empire–style house on the corner, owned by Andrew Jennings, one of the lawyers for Lizzie Borden in the axe murder trial. At the end of the street, third from left, stands a white house built by James Steers and later owned by Judge James M. Morton, a federal judge who heard and denied the final appeal in the Sacco and Vanzetti case in 1927.

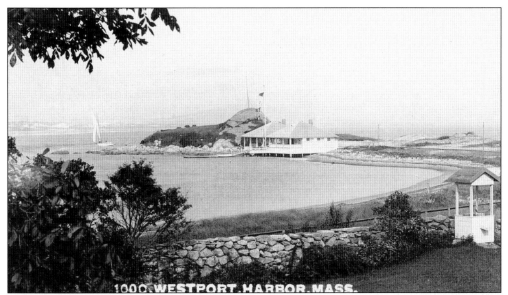

The Point of Rocks, marking the entrance to Westport Harbor, was the scene of many yacht races throughout the summer months. Children and adults alike competed for the Charlton Cup awarded at the end of each season. Westport Harbor Yachting Association boats were 15-foot knockabouts designed by William Hand of New Bedford. The "spindle" was erected on the Point of Rocks by Hale Remington.

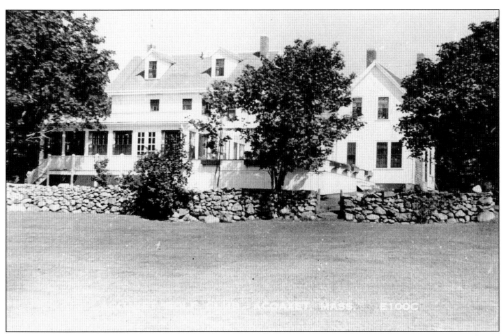

In 1919, the Westport Harbor community banded together to purchase the 165-acre Davis farm. The farmhouse was converted into a clubhouse for the nine-hole golf course known as the Acoaxet Club. In addition to golfing, the club offered tennis, sailing, and dancing, becoming the focal point for the harbor's social scene.

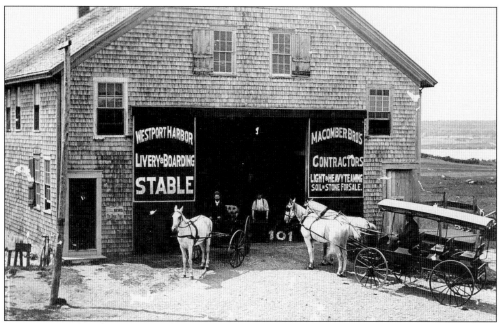

Macomber Brothers Livery and Boarding Stable, owned by Charles Macomber, provided care for the horses of summer residents. The Fall River stagecoach departed from here daily, leaving at 7:00 a.m. and arriving in Fall River by 10:00 a.m. In later years, gas pumps replaced the stable, and today the Harbor Inn is located here. The remains of Sowle's Hotel are pictured below on the right side of the building.

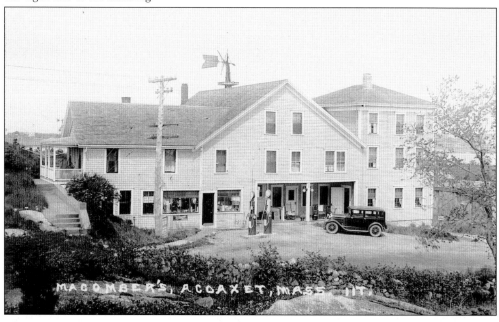

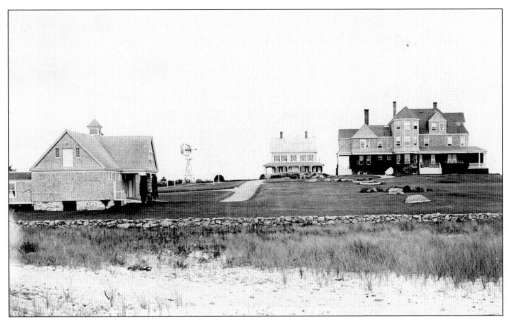

Built in the 1890s at the entrance to Westport Harbor, this mansion was originally the summer home of Henry Steers. In 1915, this shingle-styled mansion—which then belonged to Earle P. Charlton—burned down. Charlton vowed that he would build a new home that would be able to withstand the natural elements including fire, wind, and hurricanes.

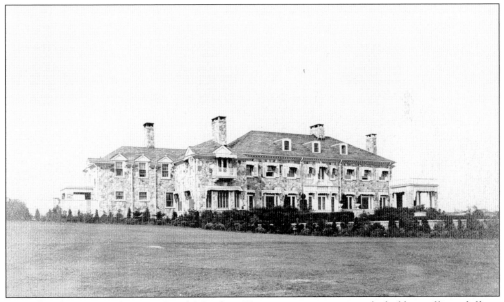

Completed in 1919, the new Pond Meadow House cost approximately half a million dollars. The exterior of the new mansion was made of granite that was 24 inches thick and shipped from Maine. Charlton brought stonemasons from Italy to handcraft the marble and granite. There were 24 rooms and 9 bathrooms in the approximately 40,000 square foot structure. The 20-acre estate also included a carriage house, greenhouses, an elaborate sunken garden, and three other homes.

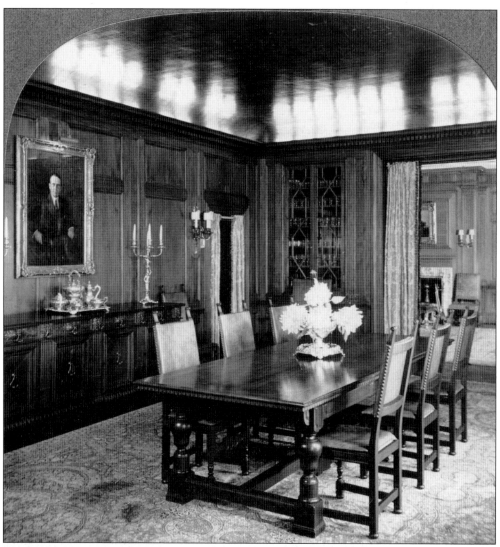

The gold leaf ceiling in Pond Meadow's dining room was typical of the sumptuous furnishings throughout the house. Born in 1863, Earle P. Charlton began his career as a traveling salesman in Boston. Through business connections made during this time, he opened a store in Fall River, eventually owning a chain of 53 five and ten cent stores throughout the United States that eventually merged with the F. W. Woolworth Company. On his death in 1930, he left an estate larger than any previously possessed by a Fall River resident.

This view shows the outdoor tearoom on the southeast corner of Pond Meadow.

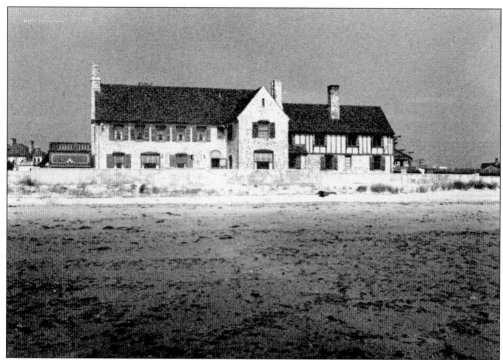

The substantial brick Mitchell house stood on the water's edge in front of Pond Meadow. Protected by a seawall, it was one of two waterfront properties that did not leave its foundation during the 1938 hurricane. However the first floor was gutted and the house damaged beyond repair.

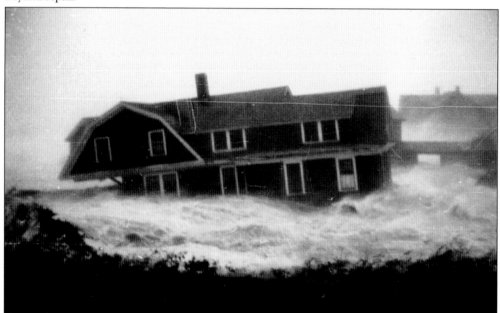

This is one of a series of dramatic photographs recording the fate of homes at the harbor during the 1938 hurricane. Of the nearly 60 cottages, 32 were simply swept away, and the wreckage deposited up to a mile from their original location.

Four

SOUTH WESTPORT

Few people today recognize South Westport as a distinct village. However at the beginning of the 20th century South Westport was a full-fledged village, with its own general store, school, church, post office, automobile repair and blacksmith shops, and telephone exchange. Its development at the intersections of Horseneck, Pine Hill, and Hix Bridge Roads probably resulted from the fact that the stage line from Little Compton traveled that way to get to New Bedford. Between 1842 and 1845, carriages ran from Westport Point to Hix Bridge Road six days a week to connect with the stage, delivering mail and other materials to and from Westport Point's residents. The village also stands on the road to Horseneck Beach where fishing, boating, and bathing were popular. By 1900, there were 21 homes near the center of South Westport.

This area also contains several of Westport's historic farms. One of these was established in the 1880s by Scottish immigrant John Smith and became known as Long Acre Farm. The farm produced prized potatoes and turnips in addition to cattle. Another Scottish immigrant, Joseph Boan, established a farm nearby. The Macombers were another large South Westport family that made an important contribution managing the general store and post office.

Community activities were centered on the river, which was well utilized for fishing, crabbing, clamming, and eeling, as well as for sailing, rowing, and paddling. The river was also an important transportation route used by farmers. In the early 20th century, Remington's Clambake and Gift Shop, situated at the foot of the bridge, became an attraction for people from New Bedford and Fall River as well as for locals.

Although South Westport has lost its village over the years, it has retained its rural atmosphere and is prized as a residential area, with its vineyards, fields, trees, and open space. Today many older residents still remembered it as "their village."

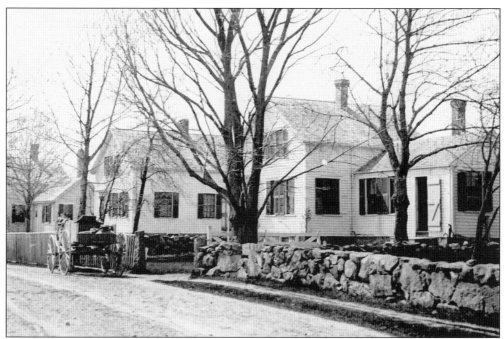

Seven houses of similar design stand in a row on Hix Bridge Road. Two of these houses are pictured here. Among these houses was the telephone exchange after its transfer from Horseneck Road. The telephone exchange operated from here until 1953. (Courtesy of Cukie Macomber.)

Here is a view of houses from the intersection of Pine Hill Road with Hix Bridge Road. The building on the right was the original blacksmith shop, which later became an automobile repair shop for Carlton Macomber Sr. Directly adjacent stands the general store. (Courtesy of Cukie Macomber.)

Charles R. Tallman's general store serviced the surrounding farms. It housed the post office and served as a stop on the stagecoach route from Little Compton to New Bedford. The store is pictured here in the early 1900s with Tallman's delivery wagons waiting outside.

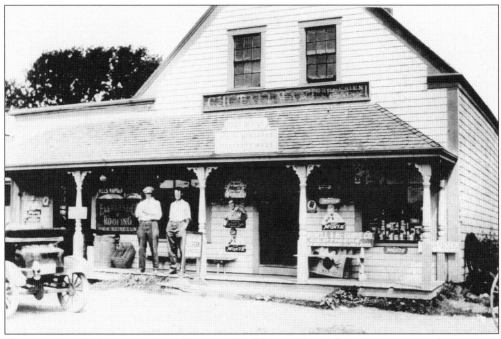

Shown in this 1925 photograph are Clarence "Bert" Macomber (right), the manager and postmaster, and George Little Sr. (left), postman. Advertisements for the beverage Moxie, an old-time soft drink, adorn the exterior. The store closed in the 1960s. (Courtesy of Cukie Macomber.)

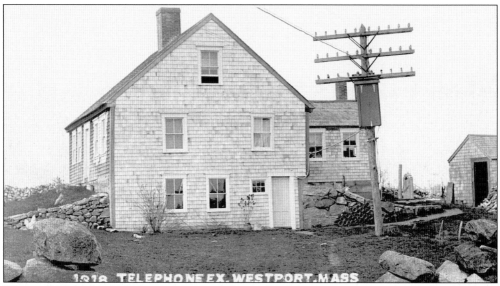

Westport's telephone exchange operated from this house on Horseneck Road. The early telephone system offered little privacy. There were party lines, with each "party" having a certain number of rings for recognition. A call was made by turning the crank the number of times that corresponded to the party called. Since everyone was aware when a call was being made, anyone could listen to the conversation.

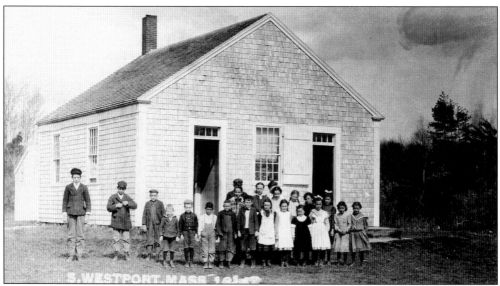

Children stand with their teacher outside South Westport School on Horseneck Road. Built in the 1860s, the one-room school served three elementary grades. Facilities were basic, with heat provided by a wood-fired furnace. Outhouses were located at the rear of the building and water was brought in from a pump located at the center of the village. This building became a community center in the mid-1930s.

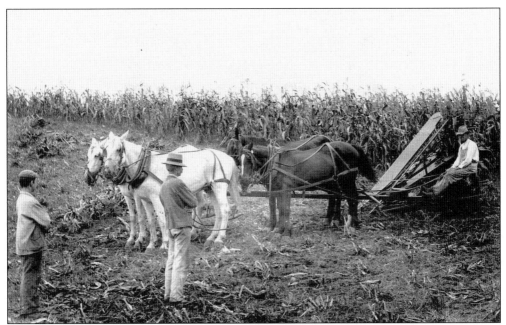

Sam Boan is pictured here cutting corn with a corn binder. Boan Farm, located on Hix Bridge Road, was established by hardy Scotsman Joseph Boan in the 1880s. Typical of Westport farms, the Boan farm grew potatoes and the famous white-fleshed Macomber turnips. Much of the produce was shipped to wholesalers in Providence.

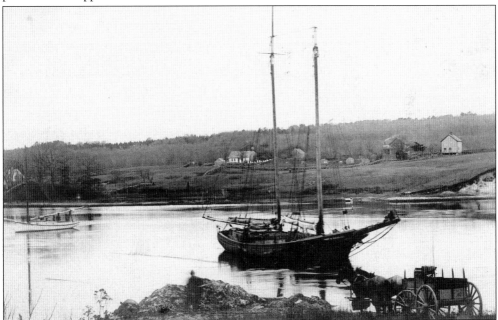

The river was a busy working waterway into the early 20th century. Pictured here, a schooner approaches the landing south of Hix Bridge with a cargo to be loaded onto the waiting buckboard wagon. On the left, a man tends the shell dump, probably from Remington's clambake. Across the river on the right is the edge of the gravel pit, and on the far left, two men ready a catboat for sailing.

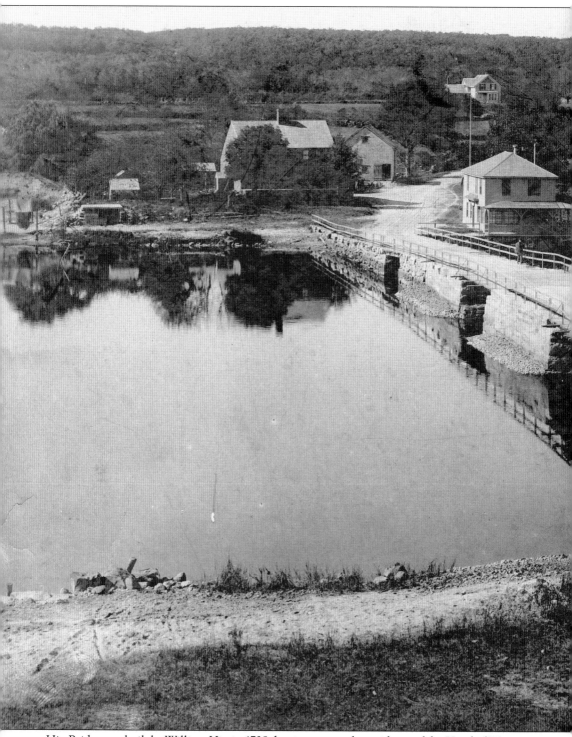

Hix Bridge was built by William Hix in 1738 despite protests by residents of the Head of Westport, who claimed that it would obstruct their boating trade. Hix prevailed and even charged a toll. The bridge spans the east branch of the Westport River (formerly known as the Noquochoke)

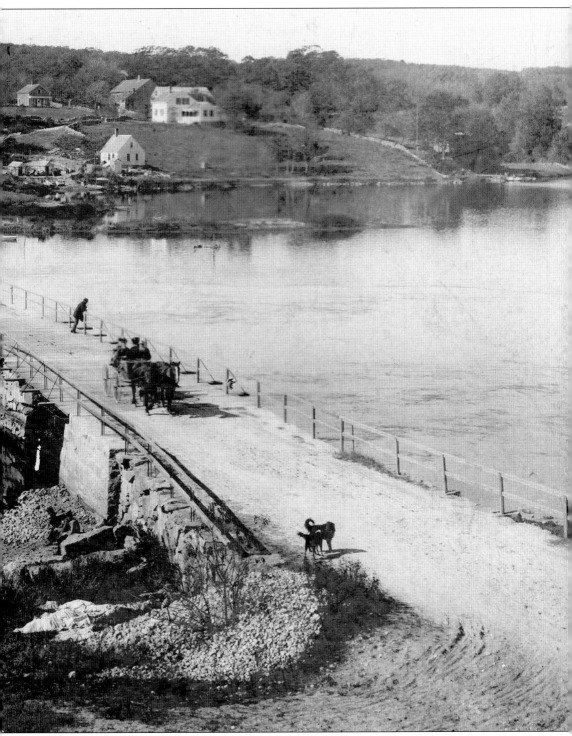

and marks the site of a Native American crossing. By 1707, there was ferry service. The wooden roadway on the old bridge was destroyed in the 1938 hurricane, and a new cement bridge was built in 1939. Pictured here, two boys test a model yacht at the foot of the bridge.

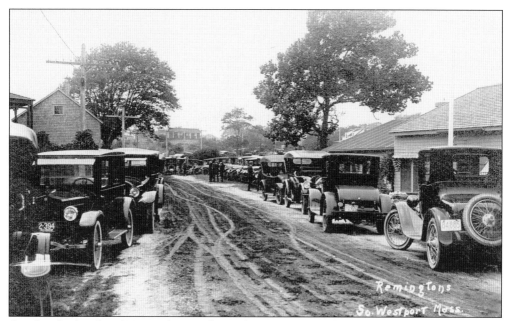

Cars line both sides of Hix Bridge Road outside Remington's Clambake Pavilion. Established in 1915, Amasa E. Remington's clambakes were a major summertime attraction for over 40 years. Held on the northwest bank of the river on every Wednesday and Saturday, the clambakes attracted a "sturdy middle class" clientele who were used to cloth napkins. Remington's Clambake Pavilion was swept away during the 1938 hurricane.

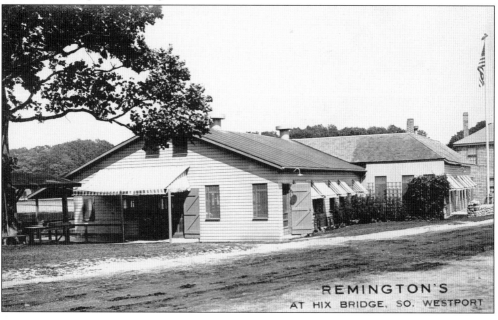

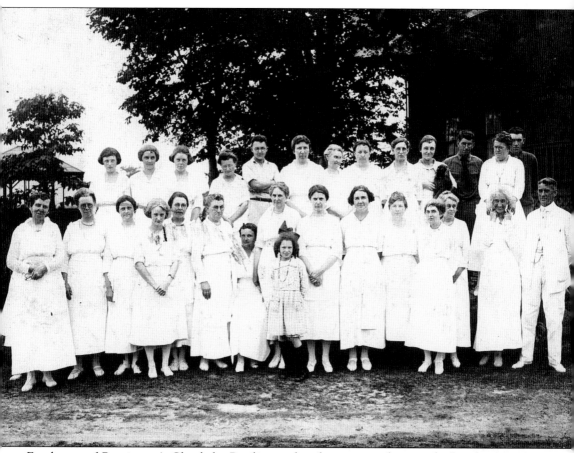

Employees of Remington's Clambake Pavilion gather for a group photograph. Local women worked as servers and food preparers at Remington's Clambake Pavilion. Remington was very concerned with their appearance and cleanliness, so they wore spotless white dresses and aprons. Pictured in the second row are bake master Ralph Macomber (right) and his assistant, John Bowman (third from right).

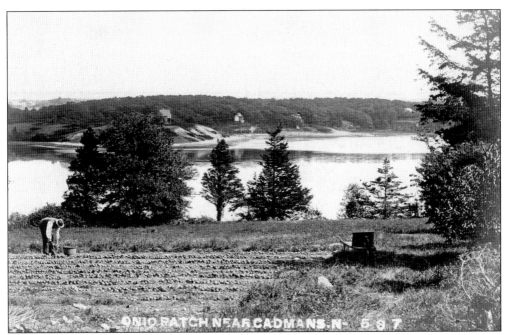

In this view from Drift Road over to Cadman's Neck, a farmer is tending to his onion patch. Onions were pulled up in the fall and allowed to dry on the ground before they were gathered and stored for the winter. The main crops in the late 1800s and early 1900s were potatoes, turnips, and corn.

Cadman's Neck, named after the early-18th-century settler George Cadman, was the site of camp meetings held by the Union Sunday School Association. Beginning in 1878 in Cortez Allen's grove on the river, these four-day outdoor meetings attracted thousands of participants. Tents fronted the water, commanding a fine view of the river. They had their own well and wharf for boatmen.

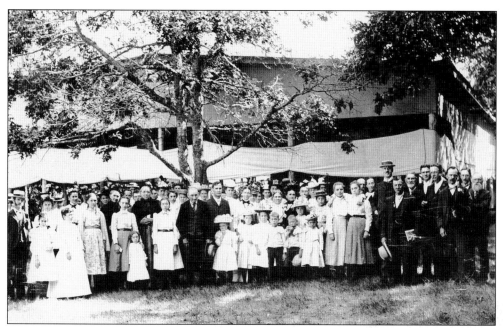

In this photograph, a group gathers for a camp meeting on Cadman's Neck. After the initial success, the meetings became an annual event that continued into the 1940s. The lively and loud nature of these meetings led locals to dub attendees "Holy Jumpers."

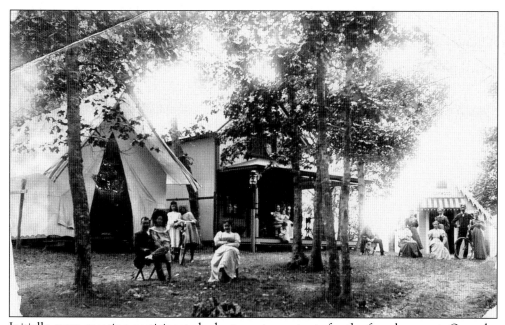

Initially camp meeting participants had set up canvas tents for the four-day event. Over the years, many of the tents were replaced by cottages, and gradually Cadman's Neck became a summer community for wealthy New Bedford and Fall River vacationers.

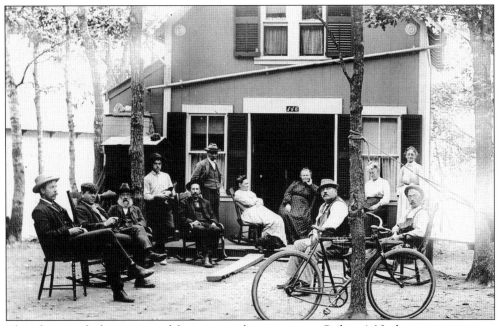

This photograph shows a peaceful scene outside a cottage on Cadman's Neck.

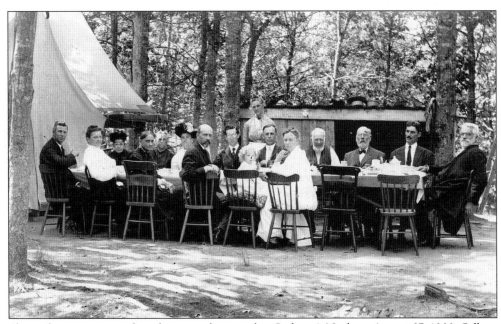

Shown here, a group gathers for an outdoor meal at Cadman's Neck on August 27, 1909. Gilbert Wordell, fourth from right, ran a refreshment building and was famous for his clam chowder.

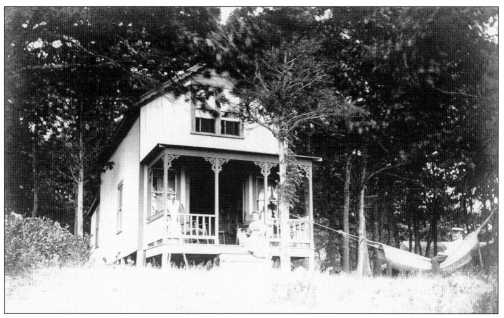
Another charming Cadman's Neck cottage is pictured here with its occupants on August 30, 1907.

Gilbert Wordell (left) and the minister (right) sit on a bench overlooking the Glen, a deep gully with solid ledges on each side located on Old Horseneck Road.

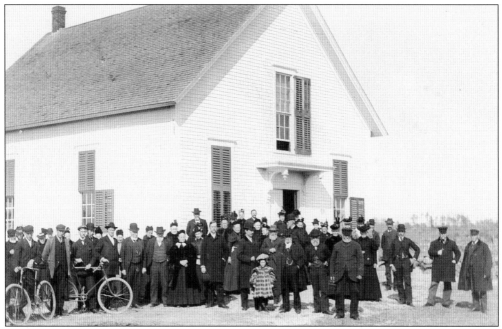

A large congregation, dressed in their Sunday best, gathers outside the Second Christian Church. Located on Hix Bridge Road, this building served as a church from 1876 until the 1950s. The remaining members decided to sell the building and land in the 1980s. The church's first minister was Mathias Gammons.

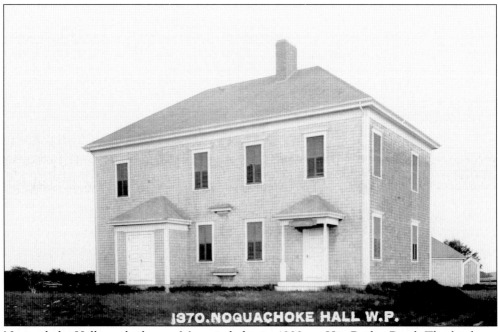

Noquochoke Hall was built as a Masonic lodge in 1900 on Hix Bridge Road. The land was donated by Cortez Allen, a prominent local landowner. Prior to 1900, the Masons met in a building at the west end of Hix Bridge.

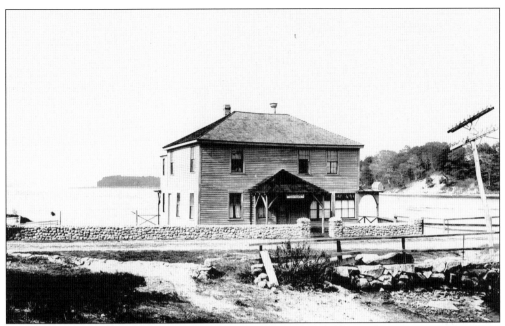

Noquochoke Cottage was located on the edge of Hix Bridge and housed a store on the first floor. The second floor was used by the Masons. It later became Remington's Gift Shop. The building was swept away with the bridge in the 1938 hurricane.

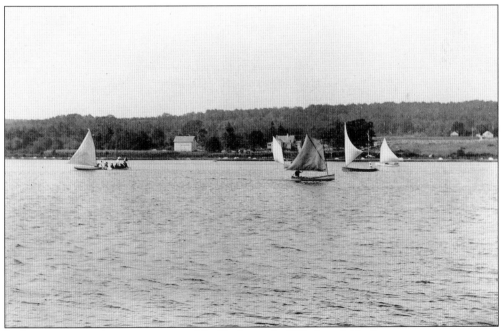

Sailing was a popular past time near Hix Bridge and off Cadman's Neck.

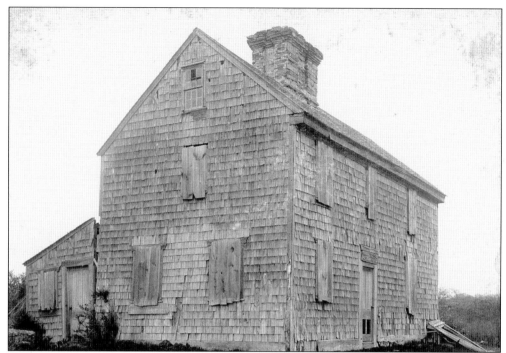

The abandoned Ricketson-Sherman House is pictured here in the early 1900s. Dating from the 1680s, it stood on a hill two miles from South Westport. The stone chimney, which furnished four rooms with fireplaces, was the last portion of the house to survive. Sadly this prime example of early Westport architecture is long gone.

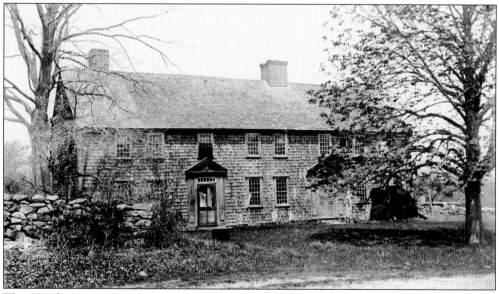

The Handy House, standing at the intersection of Hix Bridge and Drift Road, has been continuously occupied for nearly 300 years. Built in several phases, the earliest portion dates from 1710. Dr. Eli Handy, town physician, purchased the property in 1794. It remained in the Handy family until 1911. The house has been carefully preserved and is on the National Register of Historic Places with preservation restrictions for the interior and exterior.

Five

NORTH WESTPORT AND WESTPORT FACTORY

The villages of North Westport and Westport Factory are situated at opposite ends of U.S. Route 6, which slices diagonally across the northern portion of town. Both villages long predate the highway, and each developed near a body of water. North Westport and Fall River share a commercial area called the Narrows, which was originally a Native American stepping-stone path between North and South Watuppa Ponds. North Westport had its own post office, stores, sawmill, and icehouses, and despite its proximity to industrial Fall River, the area was home mostly to farms. The ponds provided swimming, boating, and ice-skating, and the area was home to nightclubs and restaurants. A railroad and an electric trolley provided easy transportation. A highway (later U.S. Route 6) linking the commercial centers of Fall River and New Bedford brought an increasing number of car dealers, an outdoor theater, restaurants, and other businesses. When Interstate 195 was built in the 1960s, the lively character of the Narrows was destroyed. However much of North Westport remains quiet and residential, with a number of farms that maintain its rural quality.

Westport Factory grew up around the mills of the Westport Manufacturing Company, established in 1854 on the site of previous mills powered by Lake Noquochoke, created by damming the east branch of the Westport River. The village was self-contained, with a post office, school, churches, a company store (open to anyone), and several rows of neat duplex factory houses. The electric trolley, built in 1894 to connect New Bedford and Fall River, stopped at the factory. Nearby was Lincoln Park, an amusement park that provided entertainment and jobs for people in the area for nearly a century. Since the Westport Manufacturing Company went bankrupt during the Depression (the huge stone factory building was razed in the 1980s), and Lincoln Park closed in 1987, the village has become a quiet residential neighborhood. The waters of Lake Noquochoke no longer provide power for the factory turbines, although the traffic along U.S. Route 6 is a reminder of the busy days of its industrial past.

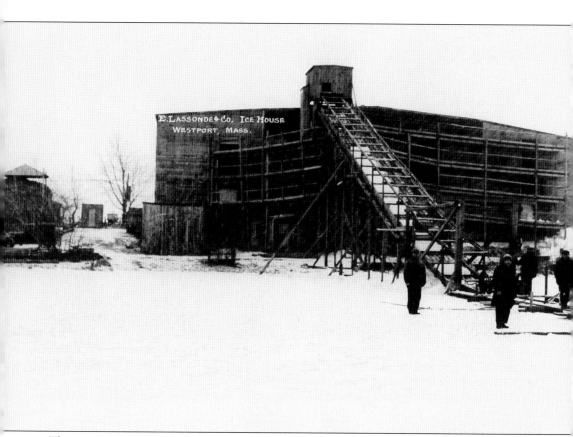

There were numerous icehouses on the ponds between Westport and Fall River, to stock the refrigerators (ice boxes) of local residents. Lassonde's was on the Westport side of North Watuppa Pond. Note the "Dutch cap" covering the hay that slowed down the melting of the ice. Lassonde's was torn down around 1940, when North Watuppa Pond became Fall River's public water supply. (Courtesy of Russ Hart.)

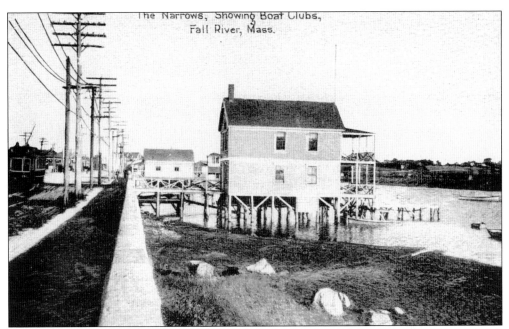

One of many boathouses at the Narrows was the Watuppa Boat Club, a private men's social club and marina. Like most buildings at the Narrows, it was torn down in the 1960s to make way for Interstate 195. Note the electric trolley on the left.

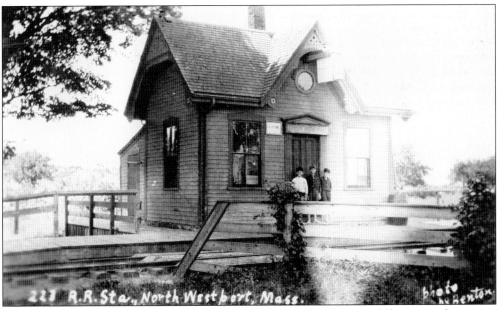

In 1872, the Watuppa Line of the Fall River Railroad opened for business. There were three stops in Westport: Juniper (at Sanford Road), Hemlock Gutter (at Davis Road), and Westport Factory (at Highland Avenue). This steam railroad carried freight and passengers, although people preferred the more convenient electric trolley when it began operations in 1894. (Courtesy of Paul Levasseur.)

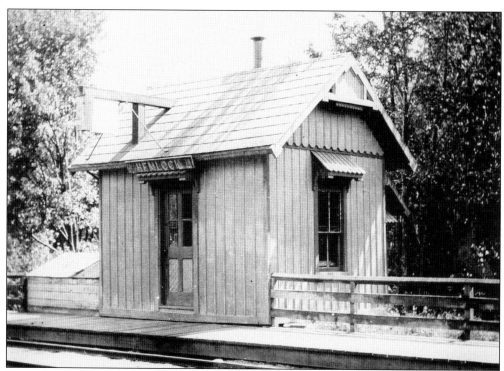

This 1910 photograph shows Hemlock station, the middle of three train stops in Westport. Officially called Hemlock Gutter, the station was located near the intersection of Route 6 and Davis Road. (Courtesy of Paul Levasseur.)

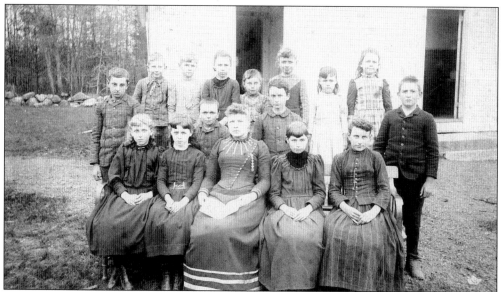

In the days before easy transportation, Westport had as many as 20 local schools. This 1887 photograph of the North Westport school shows, from left to right, (first row) two unidentified students, teacher Mary J. Fuller, Cora Brownell, and Frances Garland; (second row) Willie Nelson, Sherman ?, Warren Sherman, Lydia Gertrude Hicks, Alice Mills Blossom, Avis Pettey, Minerva Borden, Clarissa Blossom, Lottie Blair, and Waldo Sherman.

Many French-Canadian families moved to Westport to work in the mills or seek other opportunities. The five Routhier brothers built this house on U.S. Route 6, next to the family's automobile garage. (Courtesy of Jean Warner.)

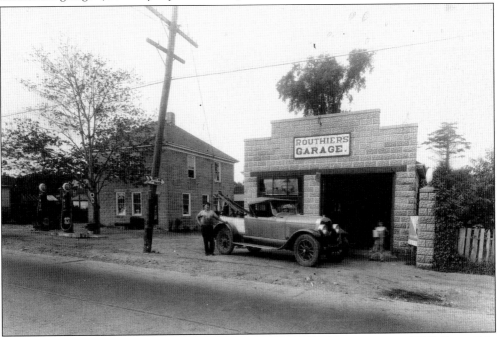

The heavily traveled road between Fall River and New Bedford became part of U.S. Route 6 in 1925, and by the late 1930s, this highway extended from Provincetown on Cape Cod to Bishop, California. In North Westport, the busy road was known for its many garages and automobile dealers. This photograph shows Routhier's Garage around 1912. The building was later used for the North Westport fire station. (Courtesy of Jean Warner.)

In the 1880s a new road was built between Fall River and New Bedford. The state took control of the road in the 1920s (it is still known as State Road as well as U.S. Route 6). Increasing traffic had its consequences; this automobile accident in 1923 killed Rev. Alfred E. Coulombe of St. George's Church.

By the middle of the 19th century, every village in Westport had one or more churches. The First Christian Church of North Westport was established in 1858. The original church building still stands, although now privately owned.

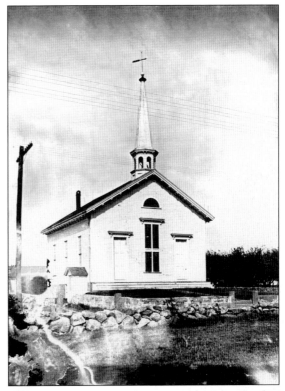

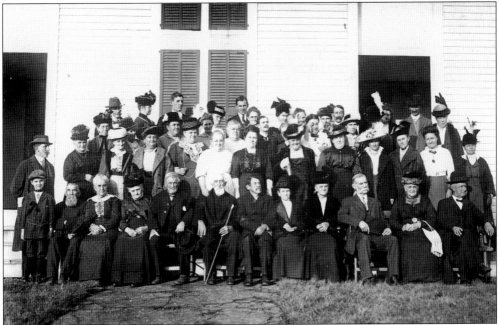

Attendees gather outside the North Westport First Christian Church. Among this group are: Wilson Sherman, Robert and Elizabeth Cottell, Thomas Pettey, Fannie Pettey, William H. Gifford, Rev. Thomas Lewis, Albert S. Sherman, Mary Sherman, Charles Graham, Alice Sanford, and Sadie Pettey.

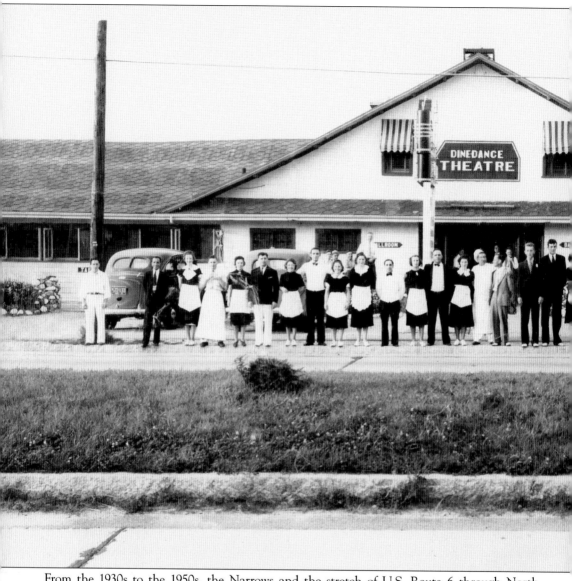

From the 1930s to the 1950s, the Narrows and the stretch of U.S. Route 6 through North Westport were the entertainment center of the area. Nightclubs with colorful names like Congo and Martinique drew popular entertainers as well as exotic dancers like Sally Rand. The Hi-Way

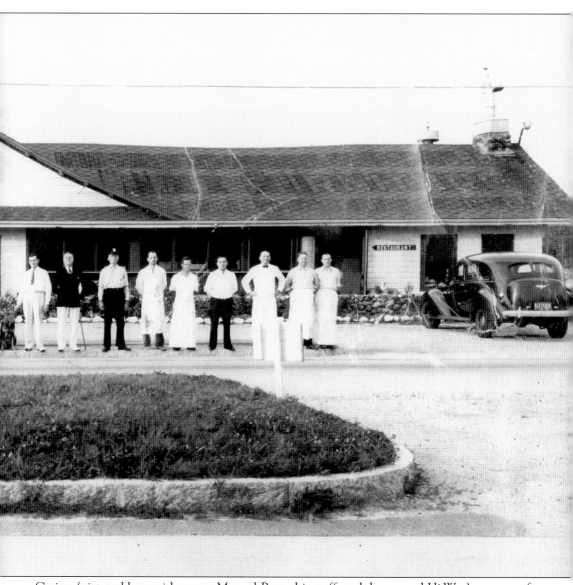

Casino (pictured here with owner Manuel Perry, his staff, and dog named Hi-Way) was one of the best-known local spots. (Courtesy of Paul and Cecile DeNadal.)

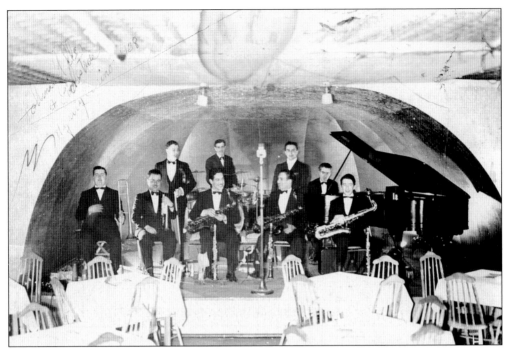

Among the many popular jazz bands that played the Hi-Way Casino was Johnnie Allen's Orchestra. Nationally-known stars such as Frank Sinatra, Tony Bennett, Dean Martin, and Jerry Lewis also performed at the Hi-Way Casino. (Courtesy of Paul and Cecile DeNadal.)

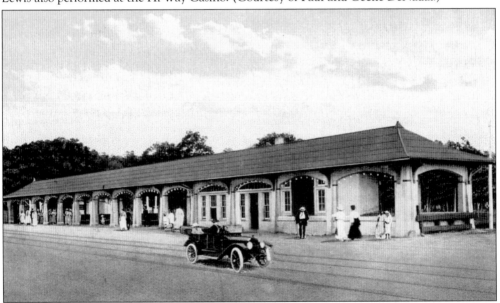

To draw more riders to its trolleys, the Union Street Railway Company built Lincoln Park in 1894. A two-minute walk from the factory, this amusement park provided excitement, jobs, dining, and entertainment for people all over southeastern Massachusetts. The most thrilling ride was the rickety wooden roller coaster, known as the Comet, built in 1947. The park closed in 1987 due to increasing operational costs and declining attendance. The trolley station for Lincoln Park is pictured here

In 1948, John "Speech" DeNadal opened Sterling Beverage, a beer distributorship on the Westport side of the Narrows. Sterling sold beer, initially Rupert Ale, to retailers and employed as many as 75 workers from the area. This photograph shows the building on opening day, which was celebrated with an open house for the public. Over 6,300 bottles of beer were consumed that day. (Courtesy of Paul and Cecile DeNadal.)

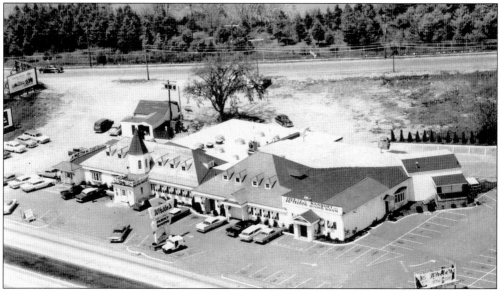

Two of the area's best nightclubs, the Lamplighter and Ruth's Victory Room, sat side by side at the Narrows. In 1955, they were bought by Aime LaFrance and transformed into White's Family Restaurant, one of the few establishments to survive the highway construction that forever changed the character of the Narrows. The main dining room is decorated in the style of the *Priscilla*, the steam-powered flagship of the old Fall River Line. (Courtesy of the LaFrance Hospitality Company.)

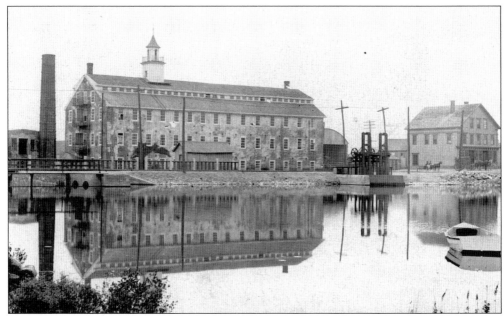

Originally established in 1854, the Westport Manufacturing Company was a major employer until the Depression of the 1930s. The factory village had a school, a general store, a church, and a hall for lectures and entertainment. The ancestors of many of the French-Canadian families in town originally came to work in the factory. This photograph taken from across Lake Noquochoke shows the four-story main factory in the early 20th century.

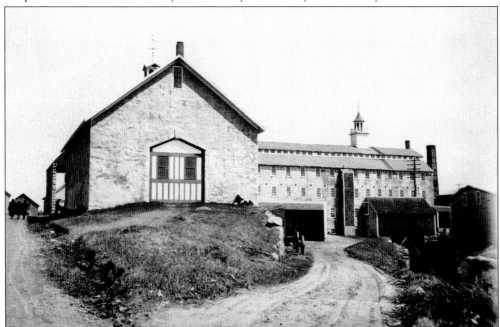

The mill produced cotton warp, batting, twine, and candle wicking from "waste cotton" purchased from larger mills in Fall River. This photograph shows the cluster of substantial stone buildings at the south end of mill No. 1. The building on the left, on Union Avenue, is the only remaining structure of the main mill complex.

In 1872, the Westport Manufacturing Company built mill No. 2 on the site of earlier water-powered mills. About a half mile from the main factory, this second mill had its own row of employee houses along Forge Road. While the main factory was demolished in the 1980s, mill No. 2 was used to make ammunition during World War II and later purchased by the Hoyt Corporation, a manufacturer of dry cleaning equipment.

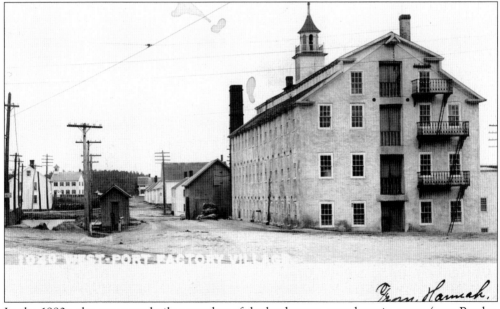

In the 1880s, the company built a number of duplex houses, seen here in a row (now Beeden Road) behind the mill. Some houses were rented and some purchased by workers, which gave the employees a stake in the community. Most of the houses are still in use today as private residences. The building on the left, with the bell tower, is the original factory school.

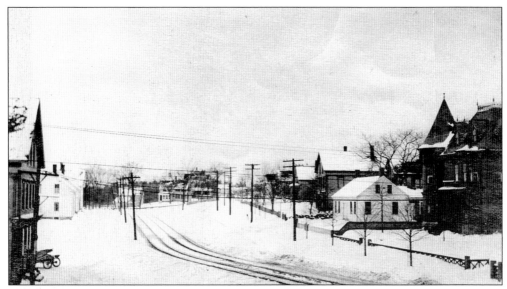

This winter scene from the early 1900s looks westward from the factory. Note the tracks of the Dartmouth and Westport Electric Railroad, a passenger line that connected the commercial cities of Fall River and New Bedford, with an important stop at Westport Factory and Lincoln Park.

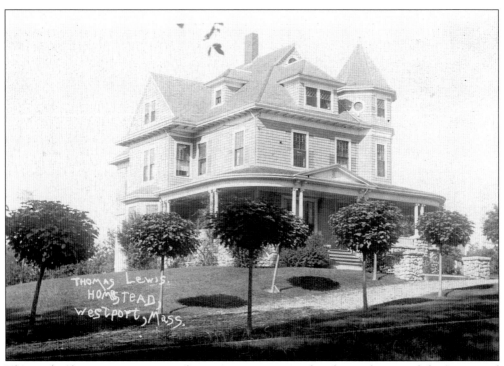

The worker housing was very modest in comparison to the elegant homes of the Lewis and Trafford families, the owners of the Westport Manufacturing Company. The Thomas Lewis house still stands on Highland Avenue, just north of the old factory site.

The Union School at Westport Factory was built in 1874 and was shared by the towns of Westport and Dartmouth. The original school was very similar to the 1841 Bell School, which still stands at the Head of Westport. This undated photograph shows the teacher and students outside the old Union School.

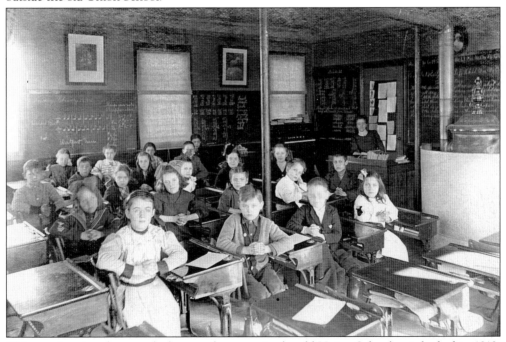

This rare interior photograph shows a classroom in the old Union School as it looked in 1912. The original factory school was replaced in 1915 by a new school, and that building is still in use as the Dartmouth Awning Company on Beeden Road.

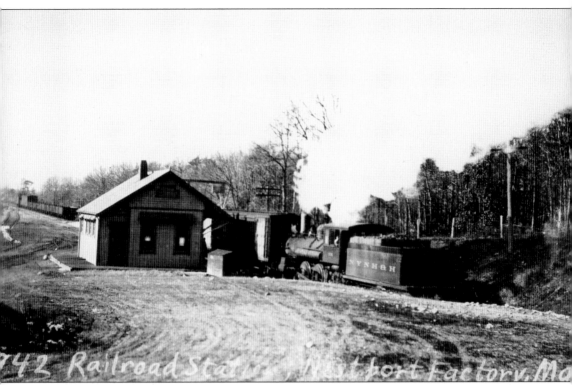

The Fall River Railroad, more commonly called the Watuppa Branch, opened for service between Fall River and New Bedford in 1872. The Westport Factory stop was almost a mile north of the mill, on Highland Avenue. Although the station is gone, trains still run to Mid-City Iron and Scrap, a metal recovery company on U.S. Route 6 in North Westport. (Courtesy of Paul Levasseur.)

Six

HORSENECK

Horseneck Beach is thought to derive its name from the Algonquian word *hassanegk*, meaning "cellar dwelling" or "a house made of stone." There are actually two Horseneck Beaches, East Beach and West Beach, and they developed quite differently. In the early 1800s, local farmers used Horseneck Beach as common grazing land for cattle, horses, sheep, and pigs. A contemporary account describes the area as consisting "principally of sandhills, and beach and a few cranberry bogs whereon grow some pitch pines, green briars and beach grass." Farmers gathered seaweed from the shoreline, and during the 19th century, many acres of Horseneck Beach were devoted to the cranberry industry. Newspaper reports from the 1860s describe the construction of a railroad several hundred feet in length, used to move sand in preparation for planting cranberry vines. Traces of these enterprises can still be found today.

By the early 1900s, the beaches of Horseneck had become a popular summer destination. Even before the construction of the Westport Point Bridge in 1894, a substantial community of houses, grand and modest, had developed along East Beach. A rail connection between Lincoln Park and East Beach was proposed but never moved beyond the planning stages. Despite the influx of summer visitors, however, the use of the beach for agricultural purposes persisted, and it was not until 1910 that the board of health finally voted to eliminate pigs, manure, and swill from Horseneck Beach.

By the early 1930s, the area had reached the height of popularity. Summer cottages, hotels, a dance hall, a bowling alley, a skating rink, and a church lined East Beach. West Beach, being a little more isolated, was not so heavily developed. Much of the development was destroyed by the hurricane of 1938, which literally wiped the beach clean of nearly all human habitations. Many residents of Horseneck Beach lost their lives, and after repeated hurricane disasters in 1944 and 1954, the community never recovered its glory. In 1955, the State of Massachusetts assumed control of Horseneck Beach, and with the construction of Route 88 and a new bridge over the Westport River, the beaches completed their transformation from remote, rural land to an easily accessible destination for day trippers.

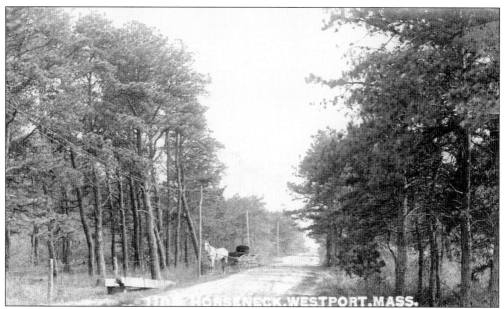

Traveling to Horseneck Beach from Westport Point was quite an arduous adventure before the construction of the Point Bridge. One summer visitor from the 1880s remarked, "looking back I marvel that they had the will and the courage to attempt it so often; it would have been much easier to forget the whole business." The journey involved rowing across the harbor and hiking through the pitch pine woods for a half mile and over the dunes on a boardwalk. However the journey was worthwhile. Pictured below are three young women, well dressed in their bathing costumes, enjoying the cooling effect of the ocean.

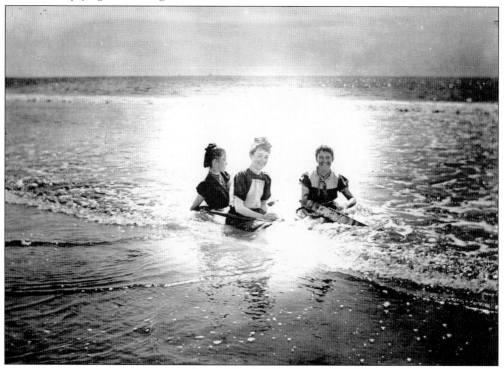

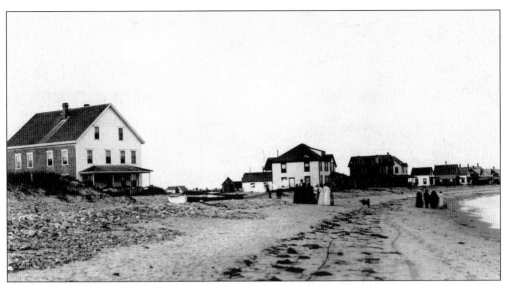

Beachgoers wander past the landmarks of East Beach. By 1895, more than 30 cottages and businesses lined the beach, which was considerably wider than it is today. Many of these buildings would be standing in the water today. From the left, looking eastward, are two of the most popular destinations: Frederick Burden Head's boarding house and a little farther along the beach stands the Surfside Hotel.

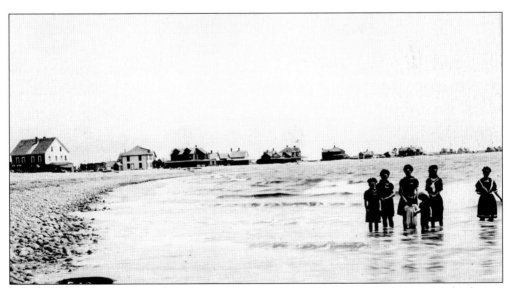

East Beach curves into the distance. Just past the Surfside Hotel stand three of the largest houses on East Beach belonging to the Trafford family, owners of Westport Factory. Beyond the Trafford houses stands the Ocean House, one of the earliest East Beach hostelries, established in 1883 by Josiah Wood.

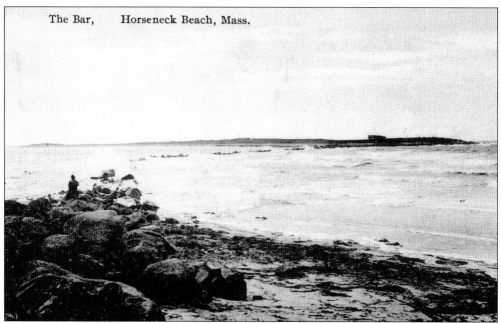

The Bar, Horseneck Beach, Mass.

A fisherman tries his luck off Horseneck Point. Prior to the construction of the causeway in 1924, the only way to reach Gooseberry Island was to walk over the bar at low tide. Pictured above on Gooseberry Island is a small building, probably a sheep barn used by local farmers. (Courtesy of Richard Jepson.)

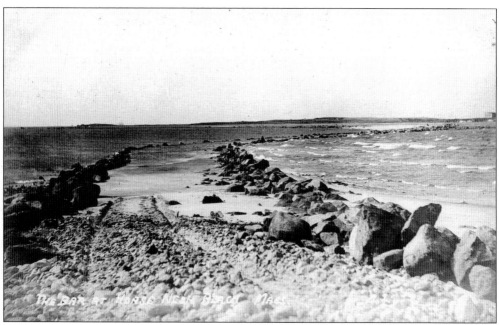

By 1922, parallel rows of stones had been placed alongside the bar in an effort to build up the causeway.

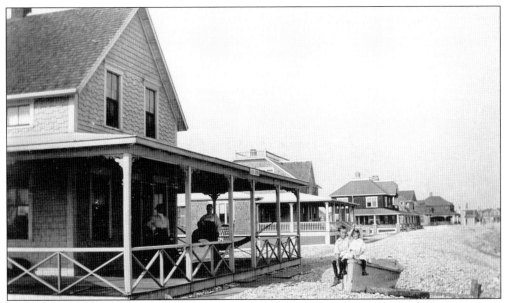

These simple cottages connected by wooden boardwalks were located just east of the Trafford mansions.

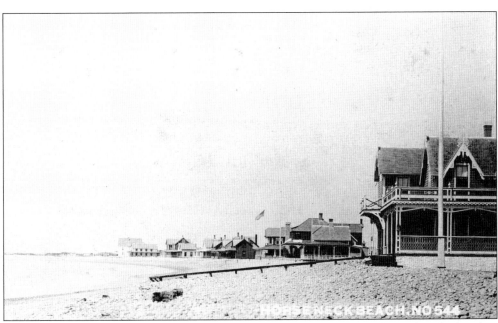

This photograph shows a view looking west along East Beach. Compared to today, the beach is considerably wider and less rocky.

Members of the Gifford family pose for the camera. By the 1890s, locals were joined by summer visitors from Fall River and New Bedford. The Giffords built one of the first houses on West Beach in 1893.

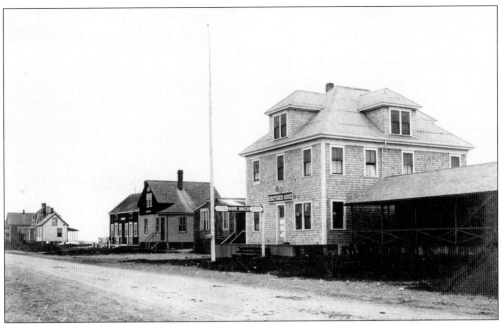

Many businesses were concentrated on East Beach Road. The Kingfisher House, owned by John T. King, served as a summer inn for visitors and residents of Westport. It also sold groceries, cold drinks, tobacco, ice cream, candy, and baked goods to day visitors. The sign to the left of the flagpole reads "Ocean View." The Kingfisher House was destroyed in the 1938 hurricane.

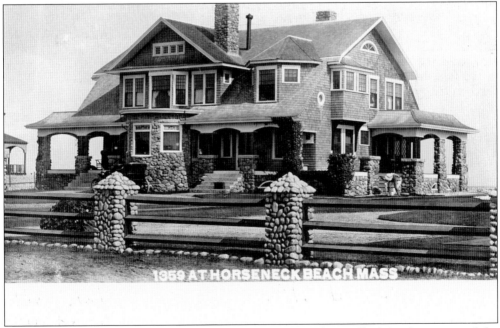

Perhaps the grandest dwelling on East Beach was that of the Trafford family, owners of the Westport Factory. Yet even this substantial structure, constructed in part from beach stone, could not withstand the 1938 hurricane. All that survived was the base of the fireplaces and a few stone posts.

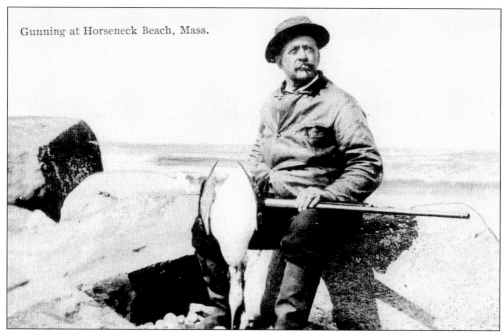

Gunning at Horseneck Beach, Mass.

Frederick Burden Head was one of the first residents on East Beach and an enthusiastic hunter. By 1876, he established a boarding house on East Beach, renting rooms to duck hunters. Head was also the second keeper of the lifesaving station. He perished in the 1938 hurricane. (Courtesy of Westport Public Library.)

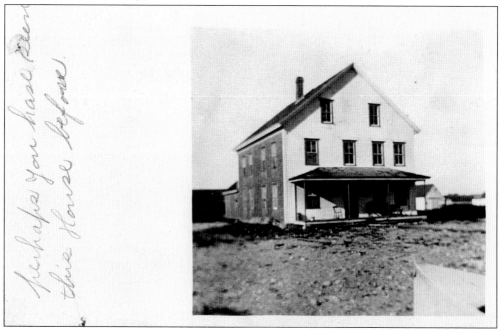

Head's boarding house stood at the western end of East Beach. Head recalled, "As many as 150 hunters roomed at my house in the early years when ducks and other fowl such as loons and quail were plentiful . . . I shot as many as 86 ducks in one day and shipped them to the markets in New York and Boston."

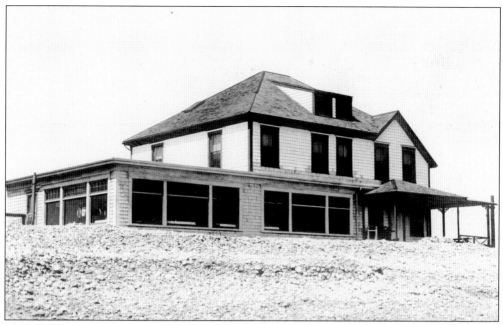

The Surfside Hotel, owned by Lydia and John Gifford, was one of the most popular and enduring attractions on East Beach. Operating initially from a tent, the business developed steadily over the years, growing into a one-room cottage that after several additions became the 16-room building pictured here. The Giffords served chowder, lunches, and refreshments to visitors from New Bedford and Fall River for over 50 years.

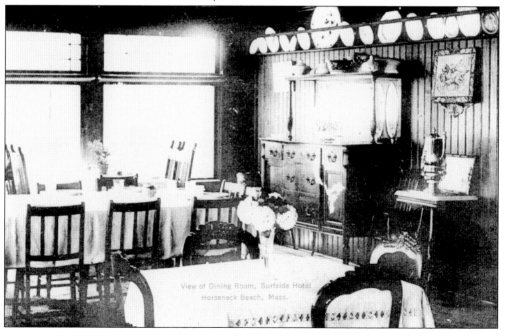

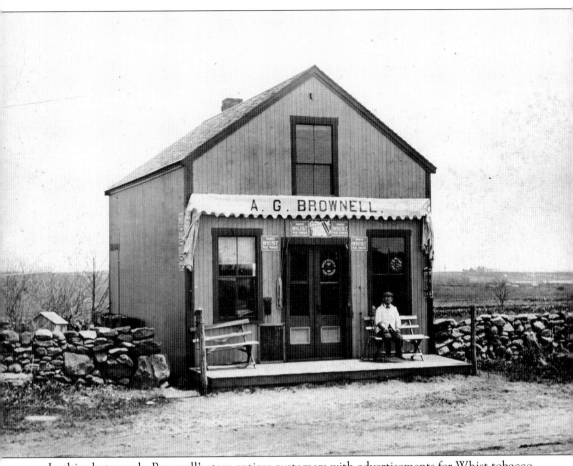

In this photograph, Brownell's store entices customers with advertisements for Whist tobacco.

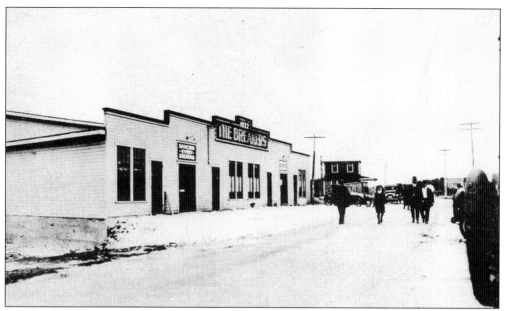

The Breakers Pavilion was one of several recreational centers on East Beach, offering bowling, dancing, and roller-skating. Here skates could be rented for 25¢ an hour. The Breakers Pavilion was destroyed by fire in the late 1920s.

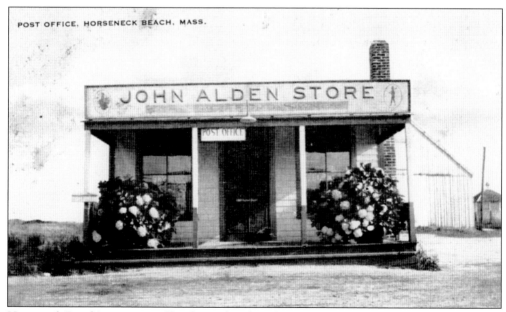

Horseneck Beach's own post office, housed in the John Alden Store, was located directly behind the Surfside Hotel. The post office and store were managed by John Gifford between 1914 and 1930.

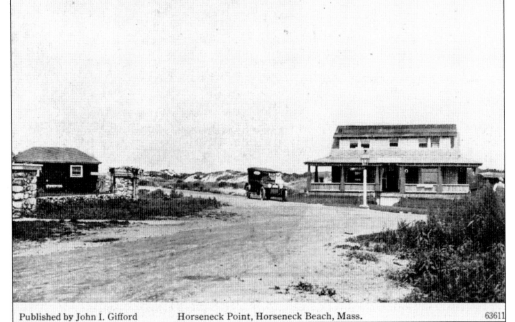

Published by John I. Gifford Horseneck Point, Horseneck Beach, Mass. 63611

The building that once housed Westport's lifesaving station at Horseneck Point was one of the few survivors of the 1938 hurricane. Erected in 1888, the station stood originally at the entrance to Westport Harbor as part of a network of lifesaving stations established by the Massachusetts Humane Society. It was later moved to Horseneck Point, where boat launchings were easier and safer. It ceased operation in 1913 and the building, as pictured here, was converted into a restaurant.

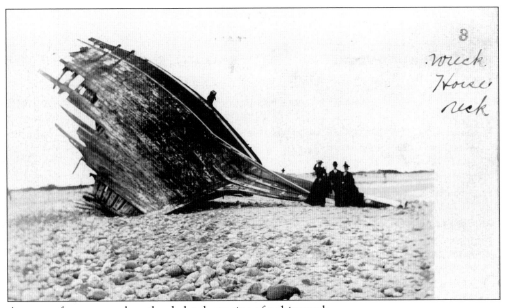

A group of women explore the skeletal remains of a shipwreck.

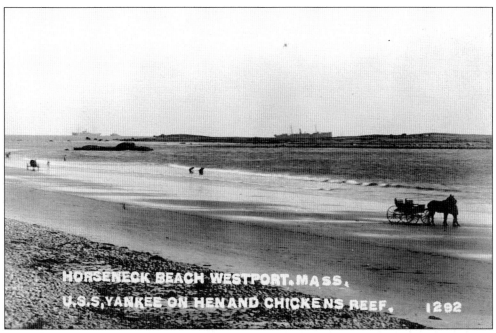

Many ships met their fate along the shoreline, among them the USS *Yankee* that ran aground on Hen and Chickens Reef in 1908. The *Yankee* was mother ship to a fleet of submarines undergoing training. En route from Cuttyhunk to Newport for a load of coal, she ran aground in dense fog. After many failed attempts to tow her to safety, she was eventually determined to be a navigational hazard to shipping and was destroyed by the U.S. Navy.

Nestled among the dunes of West Beach was a cottage belonging to Louis McHenry Howe, an advisor and close friend of Franklin Delano Roosevelt. Roosevelt visited Howe's Horseneck Beach cottage several times, traveling from Plante's Pavilion by horse drawn carriage. Beach travel was always completed at low tide when the sand was hard and wide for easy traction.

Tripp's Boatyard was founded by Frederick L. Tripp in the 1920s. Located originally on Main Road, the operation moved to Horseneck Beach in 1933 and today remains a thriving marina and boat-building and repair business.

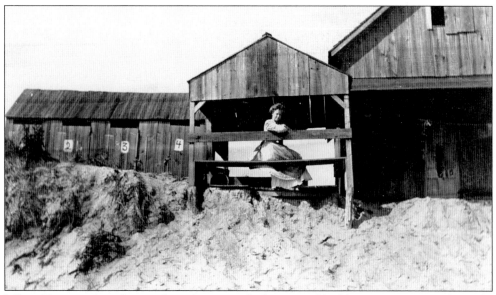

Lillian Hammond perches on the railings outside the original bathhouses on Horseneck Beach. (Courtesy of Carolyn Cody.)

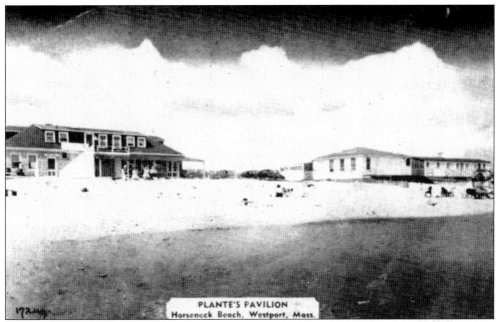

Plante's Pavilion, known later as the Spindrift, was located on West Beach at the end of Bridge Street. It served boiled lobster, steak and chips, and fried clams to beachgoers for nearly 60 years and survived numerous disasters from hurricane to fire. It closed its doors in 1958 when Horseneck Beach became a state-owned park. (Courtesy of Carolyn Cody.)

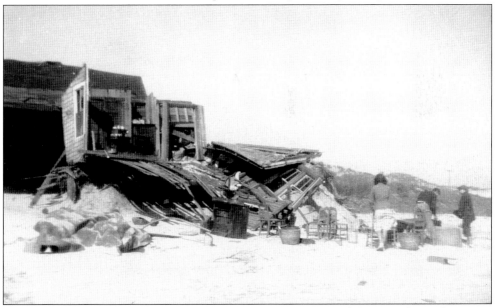

On September 21, 1938, the face of Horseneck Beach was altered dramatically. A hurricane arriving without warning, wiped out beach communities in a few short hours. In Westport, 22 people lost their lives, many of them on Horseneck Beach as they tried to save their homes. Eyewitness accounts describe how cottages were swept away like matches by waves that reached a height of 20 feet. Pictured here, beach residents sort through the remnants of their cottage. (Courtesy of Carolyn Cody.)

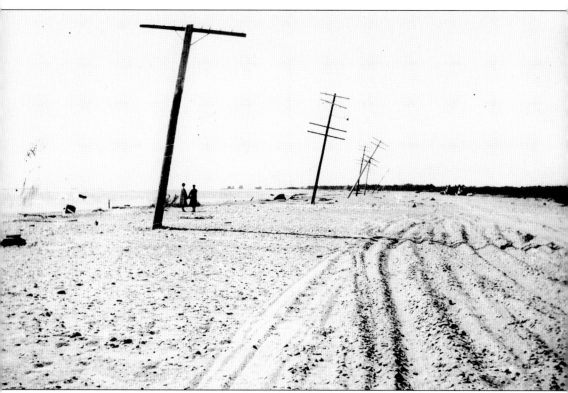

A crooked line of utility poles is all that remains on East Beach after the 1938 hurricane. (Courtesy of Carolyn Cody.)

Seven

CENTRAL VILLAGE

Due to its location at the intersection of two horse-drawn stage lines, Central Village has always been somewhat of a transportation hub for Westport. Both the stage from Little Compton to New Bedford and from Westport Point to New Bedford passed through Central Village.

It was here that Westport's first town meeting was held August 20, 1789, in the residence of William Gifford. Early town records reveal that there was much indecision as to where the Westport Town House should be located. The town considered land belonging to Stephen Kirby, then Gifford's land, and finally voted to purchase Ichabod Potter's land. The Westport Town House was completed in 1789 and stood on the west side of Main Road at the corner of Adamsville Road. A second town house was built in 1870 on the opposite side of Main Road, and in 1939, the building known today as the Westport Town Hall opened its doors.

Many of the buildings along Main Road have remained in continuous use since the 1800s and have had a variety of functions. The Quaker Meeting House was completed in the early 1800s at its present site on Main Road. Other buildings such as the Grange, St. John the Baptist Catholic Church, and the Milton E. Earle School were later additions to the village, erected between 1913 and 1924.

Central Village was surrounded by farms, including one of the earliest buildings, the Waite Potter House. A farm originally settled by Nathaniel Potter in 1700 and known today as the Oscar Palmer House on Adamsville Road is another example of a historically significant property.

Small satellite communities developed around Central Village at road intersections such as Giffords, Kirby, Woods, Booth, and Macomber corners. Most were named after families that established homes and farms in the area.

Although little reference to the name Central Village can be found until the 1850s, this village has always been the site of local town government and continued to develop into the commercial and business center of Westport in the mid-20th century. It remains defined predominantly by locally owned business of which the evolution of Lees Market from small general store into full service supermarket is the prime example.

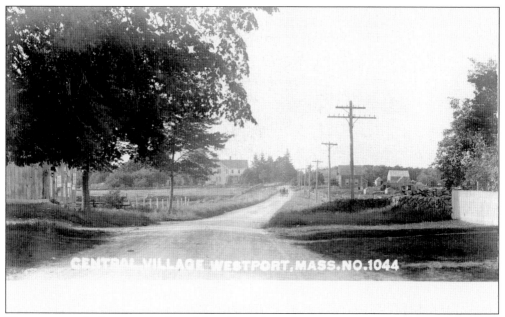

This is a view looking north along Main Road from the intersection with Adamsville Road. In the distance stands the Bowman House, which today houses Partners Village Store, one of Central Village's modern day businesses.

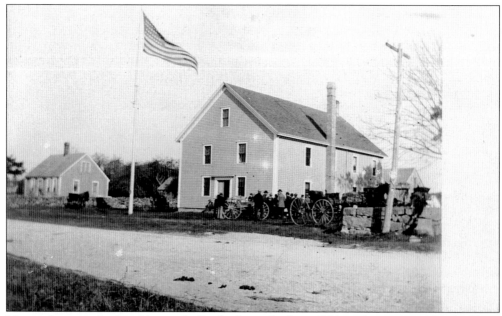

Men gather outside the old town hall, which was built in 1890, replacing an earlier building. This building is now owned by St. John the Baptist Catholic Church. The present-day town hall was opened in 1939.

Two boys on bicycles pass under the village tree on the triangle at the intersection of Main and Adamsville Roads. Behind them waits a U.S. mail horse-drawn stage near the village pump and water trough. The pump remained in use until the 1980s, when, due to contamination, over usage, and traffic congestion, the well was closed.

Central Village was a local transportation hub. Stage lines from Little Compton to New Bedford passed through the village, as did the line from Westport Point to New Bedford.

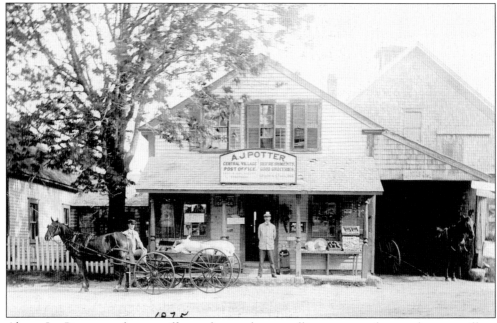

Abram Joy Potter ran the post office and general store, selling, among other goods, teas, coffees, spices, and grain. A contemporary newspaper account noted that from the outside his store "looked like a giant pin cushion but with tacks used instead of pins. The boards are stuck full of tacks that formerly held signs, many of which were of the 'Why try to kill the flies when they will freeze to death in November' variety."

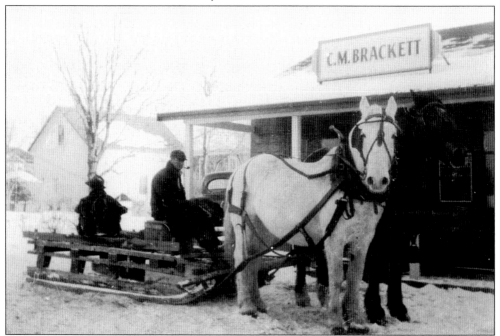

In this wintry scene from the 1940s, a horse-drawn sledge waits in front of Chester M. Brakett's store. Brakett succeeded Abram Potter as postmaster and ran a store on the south side of Adamsville Road.

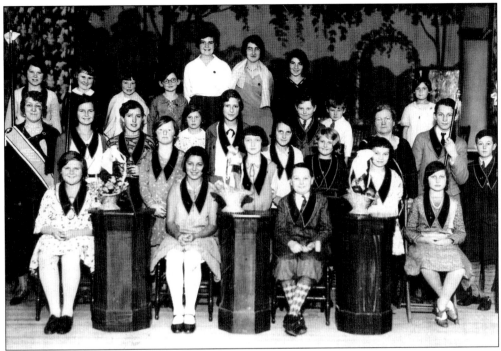

Members of the Juvenile Grange 181 in 1932 stand in front of the stage in the Central Village Grange building. In the foreground are three stations representing Faith, Hope, and Charity. One of the future masters of the Grange, Cukie Macomber, can be seen in the third row, fourth from right. The Grange, first organized in 1890, was an agricultural organization that provided a forum for local farmers and their families to meet and socialize. (Courtesy of Cukie Macomber.)

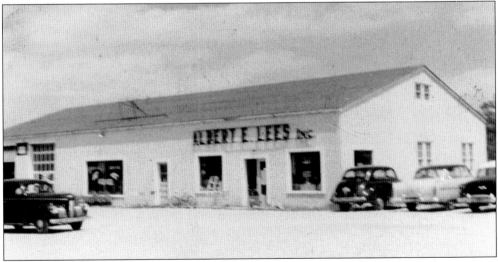

On March 19, 1949, Al Lees Sr. opened the doors to his 800-square-foot general store at its original location at 1296 Main Road. A rack of bread and evaporated milk was introduced into what was then a general store to help bring in customers on more regular basis. By the 1950s, the business had moved into a new 5,000-square-foot general store (shown here) that now forms part of the 52,000-square-foot, full-service food store, a landmark business of Westport. (Courtesy Albert E. Lees III)

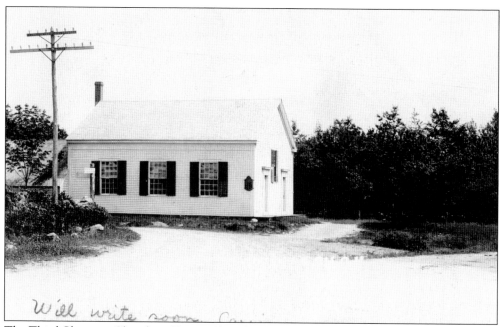

The Third Christian Church, or Knotty Shingle Church, was built in 1842 on the corner of Hix Bridge and Main Roads. A fire destroyed the building in 1947.

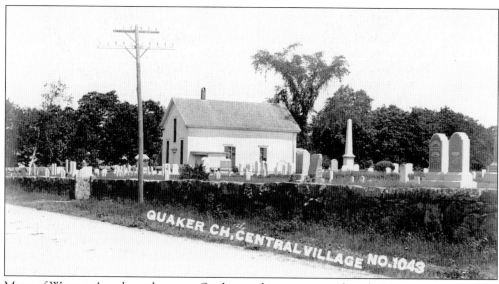

Many of Westport's early settlers were Quakers seeking to escape the religious persecution of the colonial government. The Acoaxet Meeting was established as a separate entity in 1699 and the first meetinghouse built in 1716 near the location of the present Friends Meeting House. Paul Cuffe was among those who financed the current Friends Meeting House, which was constructed in 1814. Cuffe and his wife, Alice, are buried here.

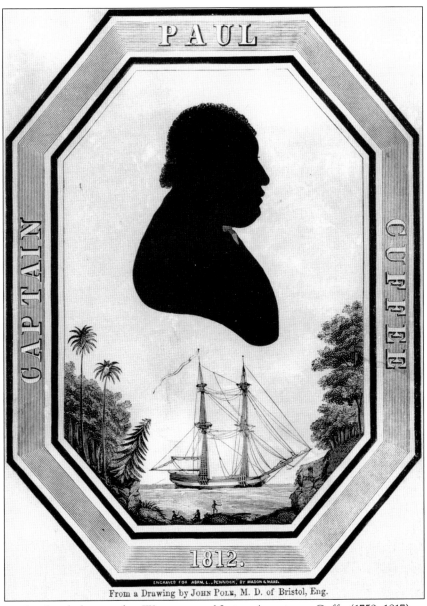

PAUL

CAPTAIN

CUFFE

1812.

ENGRAVED FOR ABRM. L., PENNOCK, BY MASON & MAAS.

From a Drawing by JOHN POLE, M. D. of Bristol, Eng.

The son of a freed slave and a Wampanoag Native American, Cuffe (1759–1817) carved a successful life as farmer-mariner in Westport. Records suggest that he purchased a 140-acre riverfront farm on Drift Road. He built a fleet of ships that progressed steadily from small open boats for local fishing and trading to larger vessels such as the *Traveller* (109 tons) built in 1807 and used to pursue his dream of returning slaves back to Africa. He became one of the wealthiest African Americans of his time and is also notable as an educator, establishing one of the first integrated schools in the United States. Typical of many Quakers, this silhouette is the only known contemporary depiction of Cuffe and illustrates his centrality between America and Africa. The brig *Traveller's* bow points towards the New England shoreline, and the stern points to the palm-lined West African coast. He envisioned a triangular trade between Africa, Europe, and America, a dream that encompassed not simply the return of slaves back to Africa, but a dream for creating an environment for economic independence and pride among Africans.

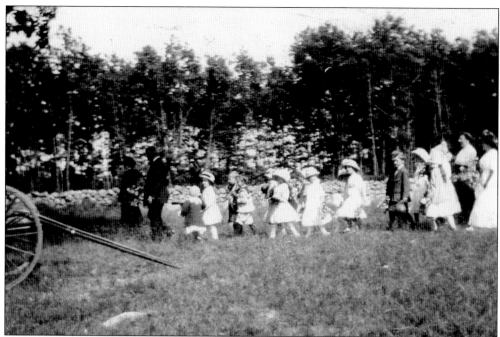

Children follow Horatio P. Howard to lay flowers at the graves of Paul and Alice Cuffe during the dedication of the Cuffe monument in 1913. Among this group are: Doris Macomber, Clara Helger, Ruth Wood, Dorothy Wood, Raymond Wood, Ann Cameron, Rachel Bowman, Luther Bowman, Stanley Gifford, Robert A. Gifford, Louise Potter, Marion Potter, Maggie Hailsworth, and Margarita F. Blake. (Courtesy of the Cruz Collection, New Bedford Historical Society)

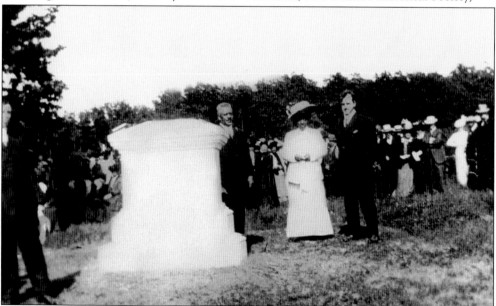

A photograph of the dedication of the Cuffe monument, June 15, 1913 shows Horatio P. Howard, donor and great grandson of Paul Cuffe; Elizabeth C. Carter, New Bedford school teacher and guest speaker; and Tom Sykes, minister of the Friends Meeting House. (Courtesy of the Cruz Collection, New Bedford Historical Society.)

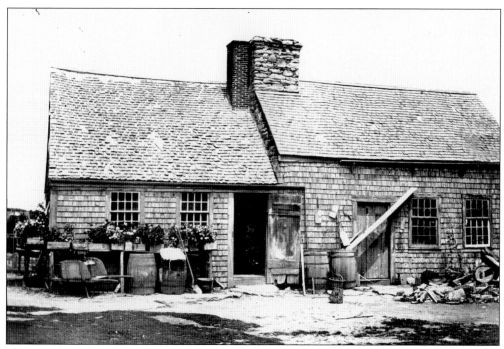

The Waite Potter house site contains the remains of Westport's earliest house, which dates from the 1670s. The house was extensively damaged in the 1954 hurricane and was dismantled. Elements of the structure were incorporated into the restoration of the Little Compton Historical Society's Wilbur House. The chimney has been preserved in its original location.

Located in Adamsville, Gray's gristmill was developed in 1710 by Philip Taber. The complex was purchased in the 1870s by Philip Gray and continues to operate today. While much of the village of Adamsville lies in Rhode Island, the mills were located within Westport's boundaries. Restoration of the millpond was completed in 2007.

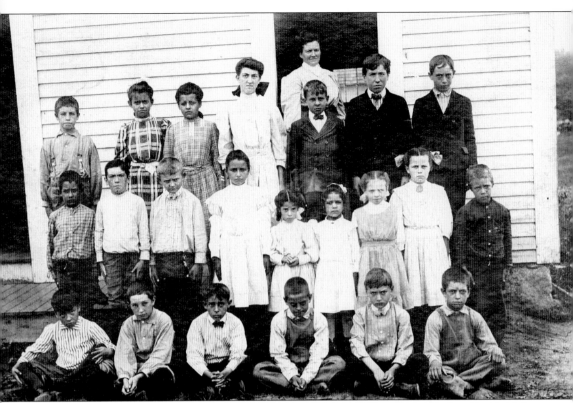

Macomber's Corner School stood at the corner of Adamsville Road and Sodom Road. Today the building is a private residence. Here teacher Kate Tallman stands in the doorway behind an unidentified group of her pupils.

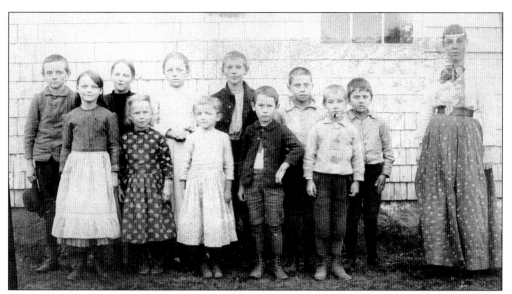

Teacher Nellie Petty stands with her class outside Kirby's Corner school located at 380 Main Road. Seen here are, from left to right, (first row) Lillian Butterfield, Cassie Butterfield, Nellie Petty, Chester Macomber, and Granville Tripp; (second row) Arthur Potter, Kitty Butterfield, Phoebe Petty, Elmer Tripp, James Kirby, and Frank Kirby.

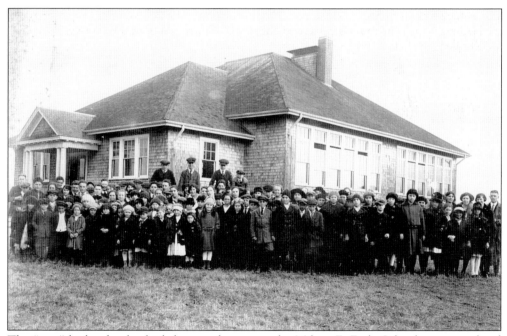

The "new" high school, which became known as the Milton E. Earle School, was completed in 1918 to accommodate up to 40 pupils and reduced the total number of schools in Westport to nine. Further additions were made to the school to accommodate more students. Today the building functions as the Westport Town Hall annex.

This photograph of Brownell's Corner looking south from Sanford Road documents a fatal car accident in 1924. The wreckage of the car can be seen over the stone wall in the cemetery.

Eight

COUNTRY AND COMMUNITY LIFE

Taken as a whole, the images in this book provide a vivid snapshot of Westport at the beginning of the 20th century. Westport's population of just under 3,000 people collected around distinct villages each with its own post office and store. There were over 400 farms, 1,209 cows, 763 horses, and 16,381 fowl. Many of the farms were small, family-run operations with a few cows, pigs, and chickens. Fishing, lobstering, and scalloping were also important means of making a living in Westport, replacing the highly lucrative whaling industry of the mid-19th century. Photographs of this era capture a town that was in transition. While a horse and buggy on a dirt road was still a common sight, the automobile was a growing phenomenon. Telephone poles lined the roads, but electricity had yet to reach many households.

The traditions of the community were influenced greatly by the agricultural calendar, with distinct flavors added by maritime culture, the influx of Portuguese and French Canadian immigrants, and the annual ebb and flow of summer visitors. Community life centered around civic institutions such as the Grange, the Masons, village improvement societies, and major annual events such as the Fourth of July parade and the agricultural fair. The fair featured the usual judging of animals, vegetables, fruits, needlework, baked goods, and preserves. Oxen, horse, and later tractor pulls were sources of competition and excitement. The fairs of the 1920s featured dog shows sponsored by Spratt's Oval Biscuits, the original commercial dog food. In 1927, "Gunfire" George leapt from a hot air balloon. Church suppers, camp meetings, dances at Alumni Hall, clambakes, and picnics brought people together after their work was done. While the community now relies less on civic groups to organize recreation, many traditional leisure activities such as fishing on the river, sport fishing off the coast, and sailing are still enjoyed by Westporters today.

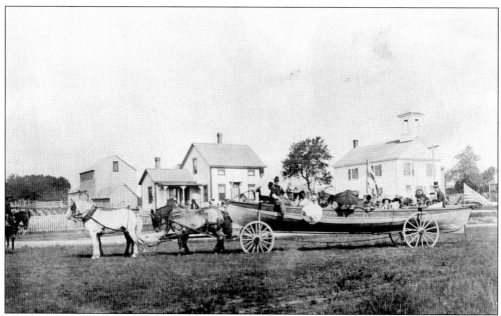

Old Home Week was a one-time festival held August 23–28, 1908, to which former residents and old friends were invited to return and visit the Head of Westport. Events included a historical day, a religious day, an educational day, and a carnival day. A participant of one of the major events, a parade, is shown here.

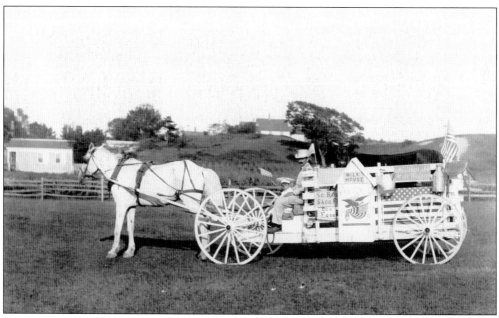

First prize, a sum of $5, was awarded to Walter King for this wagon in the Antiques, Horribles, and Trades Procession during Old Home Week celebrations of 1908. The white wagon contained a black cow, a miniature milk house, a milking stool, and a cow sprayer. King and his son also wear white. The sign on the wagon reads "Noquochoke Milk Producer" and "Noquochoke Farm."

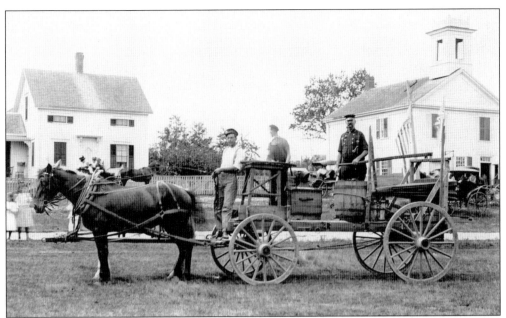

Charles Reckards, a blacksmith, received second prize in the parade. His wagon carried a full blacksmith's shop including bellows, anvil, hammers, and a forge.

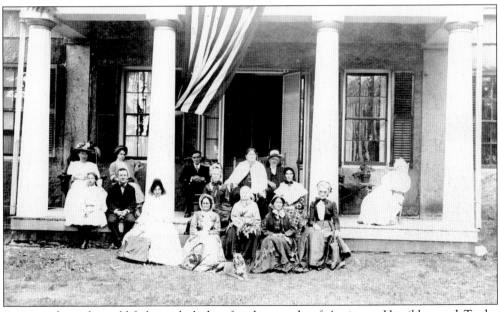

A group dressed in old-fashioned clothes for the parade of Antiques, Horribles, and Trades gathers on the steps of the Stone House. Among them are Grace Crapo, Mary Reed, Min Adams, A. C. Kirby, Mame Kirby, Cynthia Kirby, Wilfred Kirby, Mabel King, Sarah Tripp, Lizzie Little, Mrs. E. A. Tripp, and Georgianna Tripp.

You AUTO Be With Me

AT HEAD OF WESTPORT FAIR

A card advertises the Westport Fair and simultaneously heralds the age of the automobile. The advent of the internal combustion engine fueled the transformation of Westport from a predominantly Yankee community to one of relative ethnic and economic diversity. In 1907, the Westport Board of Selectmen set automobile speed limits of 8 miles per hour in the villages and 15 miles per hour in other areas. By 1929, there were a total of 1,434 motor vehicles in Westport.

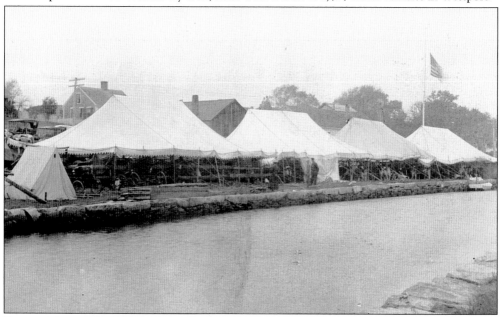

Fairground tents spread out along the river at the Head of Westport. The Westport Fair and Cattle Show was held annually at the Head of Westport beginning in 1911 and continuing into the 1930s. In the early years, it was held on the west landing and later moved to the east side fairgrounds. The tradition was resurrected in the 1950s and remains an annual Westport event.

This photograph shows the entrance to the Westport Fair as it appeared about 1912. A brochure from that year proclaimed it as a country fair run by country people to encourage agriculture, with no gambling, vaudeville, or immoral side shows. "Our grounds are on the village green, but you will see there the finest body of men, women and children that you ever saw at a fair."

The tents at an early Westport Fair included the Kingfisher Café selling hot franks and oyster stew. In addition to prizes for farm animals, fruits, vegetables, grain, flowers, baked goods, preserves, and needlework, there was also an antique show and a baby show. The largest baby under the age of one year won a silver drinking cup.

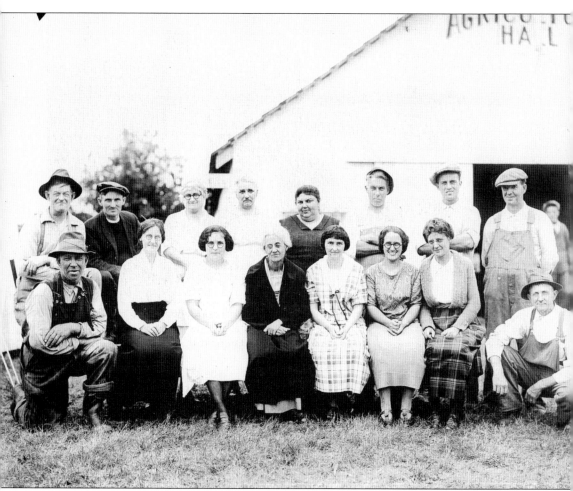

An undated photograph shows the Westport Fair Association department heads gathered outside Agricultural Hall. Among this group are Edward McGraw, Everett Tripp, Annie May Lawton, Mabel L. King, Emily Sisson, Edgar Brackett, Chester Lawton, Frank Borden, William O. Ritter, Phyllis Chase, Mary Gifford, Mildred Sherman, Mildred Schofield, Emlinda Viera, Gladys Gifford, and Charles P. Gifford.

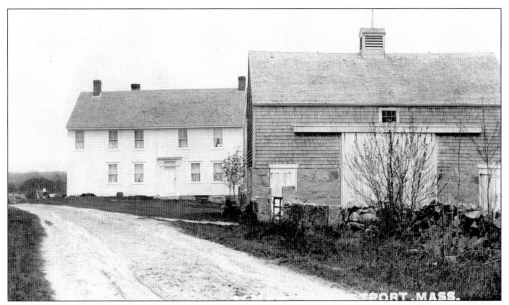

Built in the early 1700s by Stephen Wilcox, this farm was eventually utilized by the town to house the needy, the transient, and homeless. It operated as a poor farm from 1824 until the 1950s. Westport is one of the very few towns in Massachusetts that still owns its 19th century poor farm.

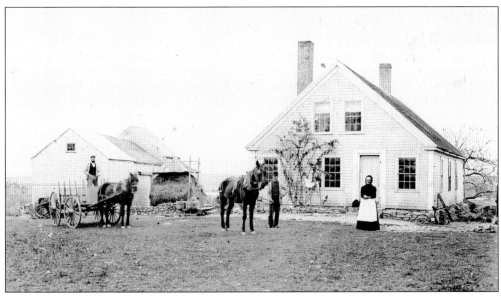

This Pine Hill Road residence is typical of the small subsistence farms in Westport. A Dutch-cap haystack stands behind the well and hand pump. The Westport River can just be glimpsed in the far distance.

This large commercial stone crusher was probably used to help pave Westport's dirt roads during the early 1900s.

Oxen haul a load of seaweed, which was an important source of fertilizer and insulation for local farmers. The right to collect seaweed was carefully guarded by Westport farmers and officially managed through permits.

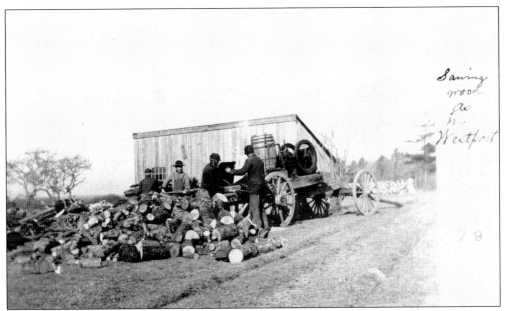

Itinerant sawyers cut logs using a portable saw mounted on a wagon. Westport's woodlands provided fuel and construction supplies, and by 1900, large tracts of land were stripped of trees, leaving only wetlands as woodlots.

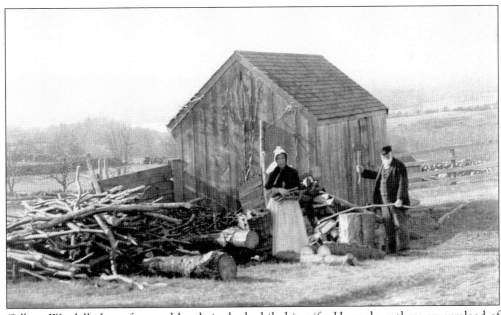

Gilbert Wordell chops firewood by their shed while his wife, Hannah, gathers an armload of kindling for the stove.

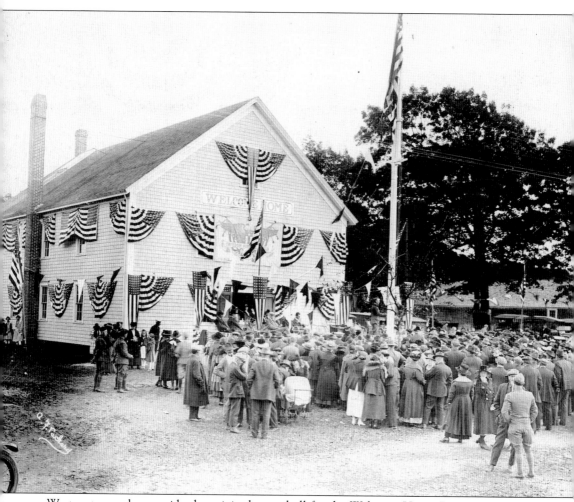

Westporters gather outside the original town hall for the Welcome Home Day ceremony held on October 13, 1919. The ceremony began with a parade of World War I veterans, followed by the Boy Scouts and other civic groups, and continued with a band concert by the Fall River Community Band and the presentation of medals. Three Civil War veterans rode in an automobile at the beginning of the parade.

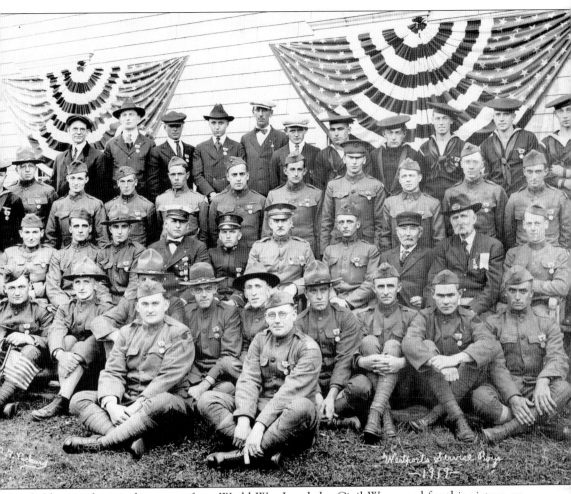

Soldiers, sailors, and veterans from World War I and the Civil War posed for this picture on Welcome Home Day. Attending the ceremony were three Civil War veterans, James H. Sowle, Christopher Tripp, and Edwin Davis. Sowle, shown here in the third row, second from right, presented the medals to the World War I veterans.

Across America, People are Discovering Something Wonderful. Their Heritage.

Arcadia Publishing is the leading local history publisher in the United States. With more than 3,000 titles in print and hundreds of new titles released every year, Arcadia has extensive specialized experience chronicling the history of communities and celebrating America's hidden stories, bringing to life the people, places, and events from the past. To discover the history of other communities across the nation, please visit:

www.arcadiapublishing.com

Customized search tools allow you to find regional history books about the town where you grew up, the cities where your friends and family live, the town where your parents met, or even that retirement spot you've been dreaming about.